117837

Alive to Art:
INTRODUCING
Subjects and Skills
José Llobera

TRANSLATED AND ADAPTED BY
W. J. Strachan

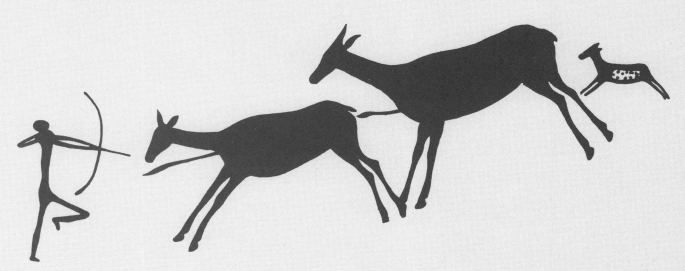

Crane Russak · New York

Introducing Subjects and Skills

American Edition 1976
Published by

Crane, Russak & Company, Inc.
347 Madison Avenue
New York, N.Y. 10017

ISBN 0-8448-0868-7

LC 75-39501

Printed in Spain

CONTENTS

AUTHOR'S NOTE

This book is not an introduction to a particular method of picture-making, nor is it a collection of specimen work to copy, nor is it a history of art, though it takes account of the latter from the point of view of appreciation especially in the two other books of the series. The sole aim is to make the student alive to the beauty around him, to discover it for himself and above all to enable him to express it in terms of picture-making.

We have the good fortune to be living in an age when art education no longer involves set tasks, the tedious copying of reality; it is much more a continual movement towards freedom in personal expression. Certainly you will find rules and instructions, but these are to be regarded solely as guides to allow you—using the techniques recommended—to choose your own path and follow it unimpeded.

One initial piece of advice: a sincere and expressive picture, even with imperfections, is preferable to a dull, photographic imitation of reality.

If you find this book and its companions entertaining as well as informative, the author will feel well satisfied.

The world of art

A marvellous world exists which begins with reality yet is situated somewhere beyond. This is the world of art, another world, another way of seeing, of understanding and interpreting the beauty of things. It is a different, inner, personal world in which the creative process takes place as in the alchemist's laboratory.

The world we live in provides us with the raw material—images, feelings, problems, joys and sorrows. In the other, *our* other world, everything is transmuted; the miracle takes place. The artistic creation which emerges is reality no longer, it is *our* reality, *our* way of seeing and feeling. And this is how it should be since art without character and personality cannot be called art at all.

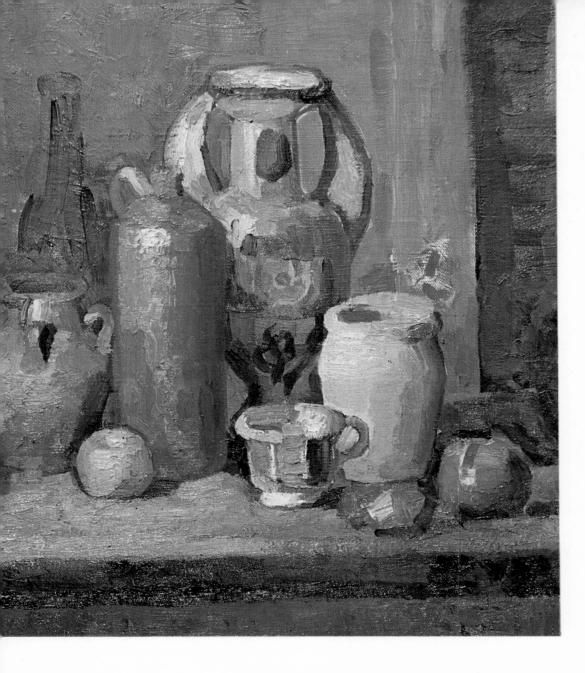

The components

of a work of art

Before dealing with the components, we should first see what art is. On this subject we could embark on a lengthy discourse and a detailed analysis, but it would all be based on the following:

Art, in the widest sense, is the personal way of doing something.

Pure art offers an individuality which sets it apart from art in general: it is devoid of practical utility.

Artistic creation executed on useful objects is known as decorative art. Needlework, hairdressing, cooking and even eating may be forms of art, but our concern is limited to the fine arts.

Among the latter, pride of place goes to the plastic arts which are: painting, sculpture, architecture.

Having established this, let us see what is required for artistic creation. The three main elements are: subject, technique and the rules governing art. As a simultaneous consideration of these three items presents difficulties, we shall analyse each in turn. This will allow you a wider range of choice. Each reader will discover the subjects most suited to his individuality, the most congenial techniques, and will be able to interpret the rules with the guidance that follows.

The subject

The subject is the thing that somehow one never manages to discover, precisely because it is so near at hand. But you don't need to ask yourself, 'What could I draw?' There's no problem. You can choose anything. Whatever you see can be a good subject. All you need do is express on paper the impact it makes on you. It is enough for you to understand its shape, its attractive features since, as you know, everything, however ugly and dull it may seem at first sight, invariably has its attractive side.

The world is full of subjects

Let us carry out a test which may make you change your mind in future about the relative importance of the subject. Here is a photograph of an out-of-the-way hamlet. Imagine you are there, facing an apparently fairly ordinary landscape. And like so many others it unites the basic features that are needed for an artistic subject. Let us pause and look at it from a distance. We are confronted with a panorama. It's got everything: a road, a stone cross indicating the beginning of a group of houses, trees and the landscape opening up at the end of the footpath. This is the subject. And as such, it serves as a starting-point for a series of sketches in which certain changes will be made because extracting beauty from it also implies idealizing, synthesizing . . . interpreting.

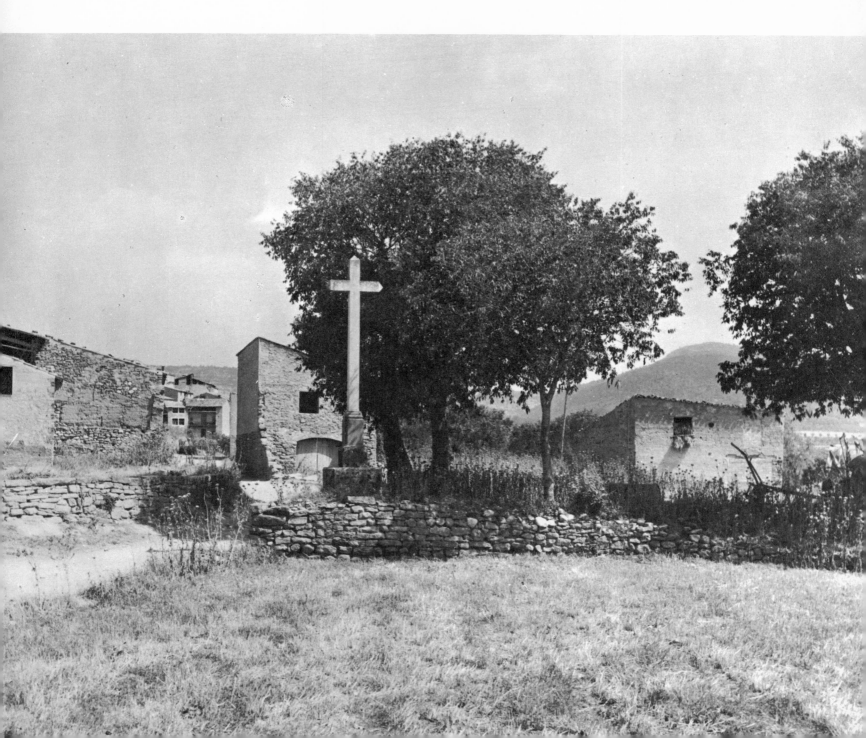

Let us begin by viewing the subject as a whole. Our aim will be to bring out the most characteristic features of the landscape: the road, the white village cross seen against the dark foliage of the trees . . . A supple wrist, a well-arranged composition and a little imagination will suffice to give the whole thing that artistic touch which will set it apart from photographic realism.

When you first look at this charcoal sketch, you may feel inclined to say, 'But this is a ready-made subject; it isn't so easy to find one like this.' You are wrong. It is in fact a commonplace and not particularly good subject because it lacks both character and individuality.

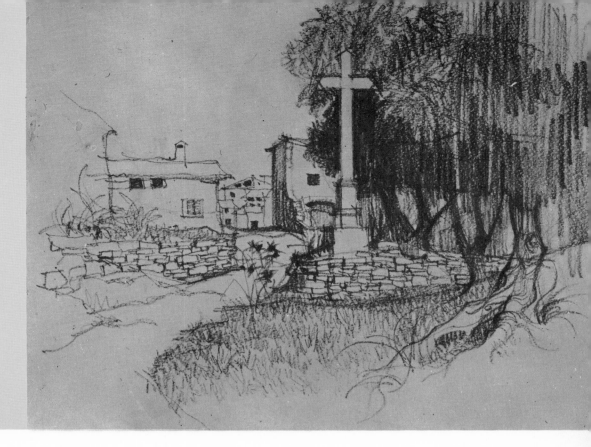

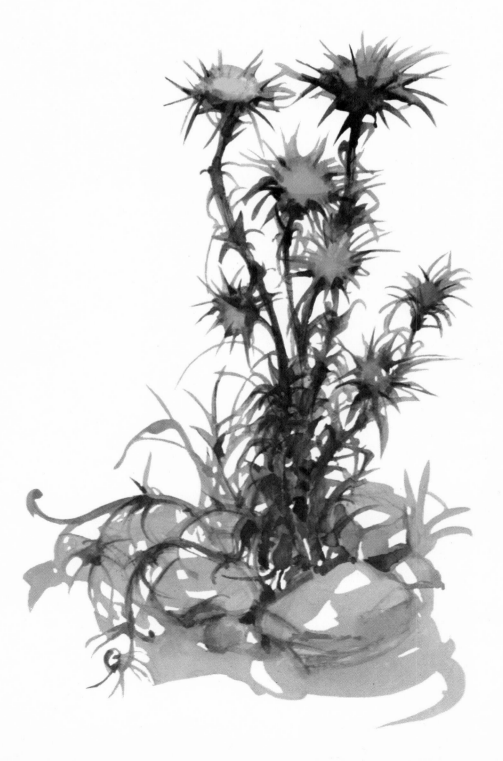

An apparently insignificant subject, however, can be more striking because so unexpected. We can test this by coming closer to our landscape in search of new angles, this time choosing a truly insignificant subject—the thistles growing at the foot of the cross. Let us set to work.

It is not a beautiful flower; it does not rival the rose or carnation. Yet, being an unusual subject with its variety of lines, its 'beards', its dry, twisted stalks, it offers many possibilities for artistic treatment. Look at the result (painted in water-colour); note how these characteristics have been exploited, even improved on. The technique adopted here has greatly helped to modify the aggressiveness of the forms.

It is important to make a careful analysis of a subject, searching out its attractive side. Without an accurate study of its individuality, you will fail to discover the fundamental forms which go to make this up.

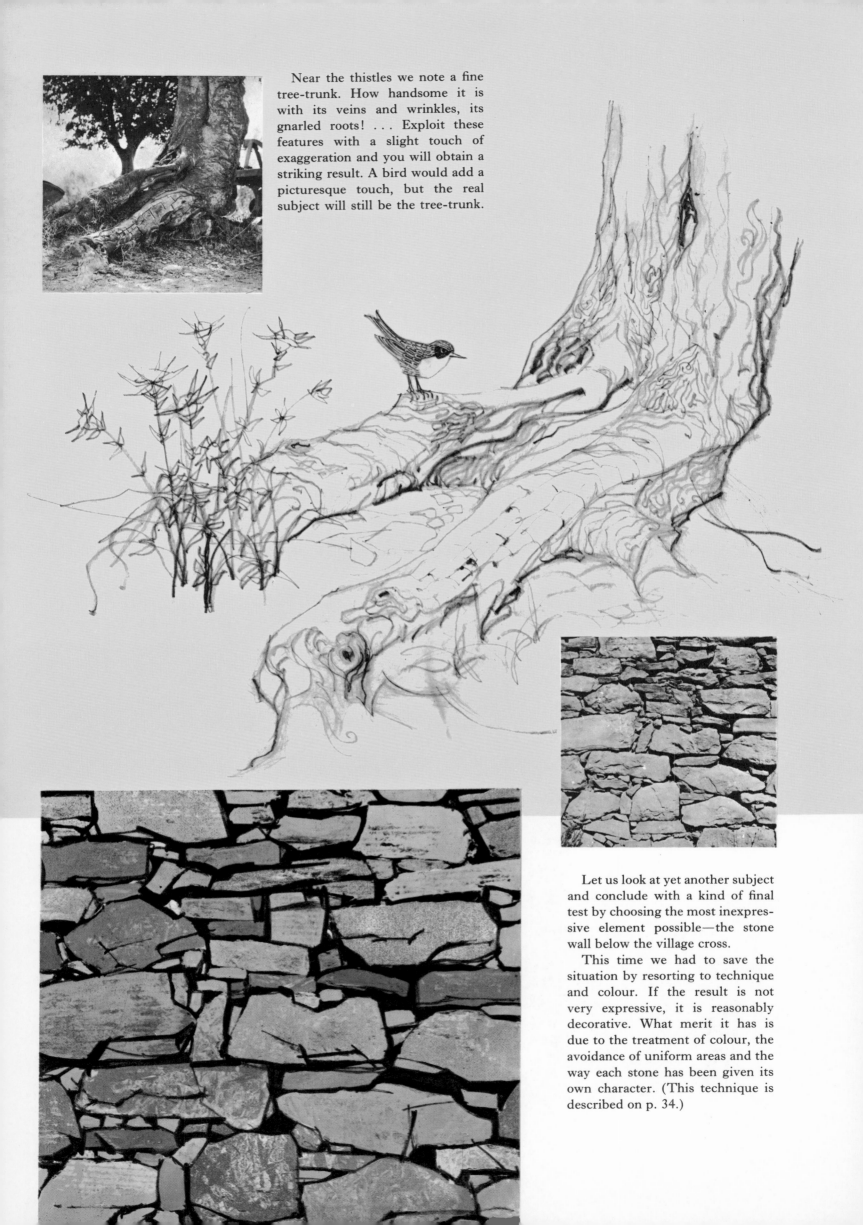

Near the thistles we note a fine tree-trunk. How handsome it is with its veins and wrinkles, its gnarled roots! ... Exploit these features with a slight touch of exaggeration and you will obtain a striking result. A bird would add a picturesque touch, but the real subject will still be the tree-trunk.

Let us look at yet another subject and conclude with a kind of final test by choosing the most inexpressive element possible—the stone wall below the village cross.

This time we had to save the situation by resorting to technique and colour. If the result is not very expressive, it is reasonably decorative. What merit it has is due to the treatment of colour, the avoidance of uniform areas and the way each stone has been given its own character. (This technique is described on p. 34.)

The evolution of the subject

Art as a mirror of history and civilization is in a continual state of evolution. Since the subject is a component of art, it too has greatly changed in the course of time.

In general, apart from artists' individual preoccupations and those of their period, restrictions and even taboos concerning certain subjects have existed at various times in history. However, the artist with traditional ingenuity has always succeeded not only in creating fine works of art but in repeatedly and consistently defeating the taboos.

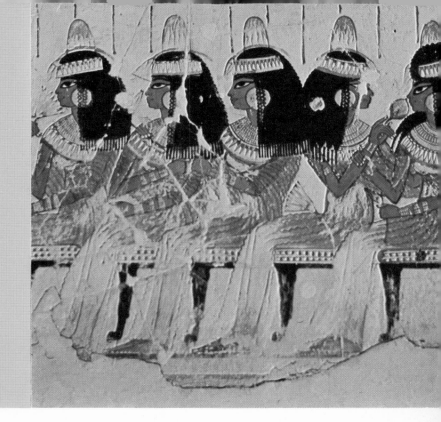

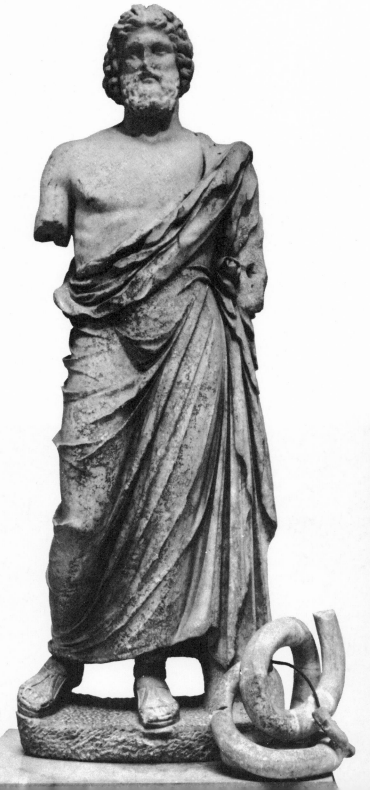

Antiquity in the Eastern Mediterranean

The most representative art of this epoch was Egyptian art. At that time artists were obliged to work exclusively in the service of the gods and kings and within a prescribed framework. No one had a right to depart from previously created forms. To do so was heresy.

Never in the course of history has there been a more utilitarian art. It could be said that for 3000 years there was no change; even those scenes which seem freely inspired had a religious purpose. Their function was to allow the buried Pharaohs to re-enact the scenes of everyday life within their tombs. In fact these paintings or bas-reliefs representing aspects of reality occurred solely in tombs.

This constant repetition of the same subjects, seen and executed for centuries in the same manner, brought technique to a high state of perfection, which formed the basis of their enduring quality.

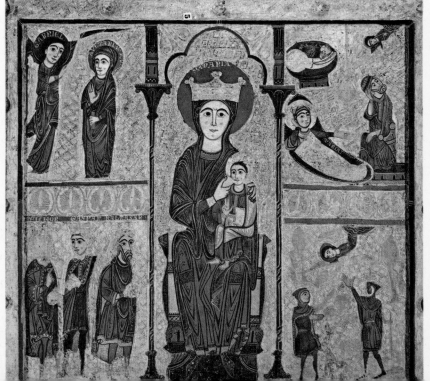

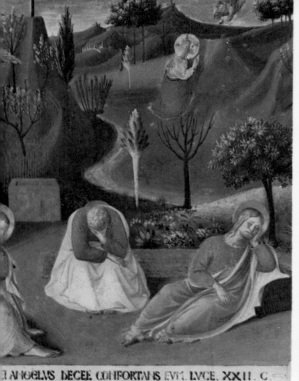

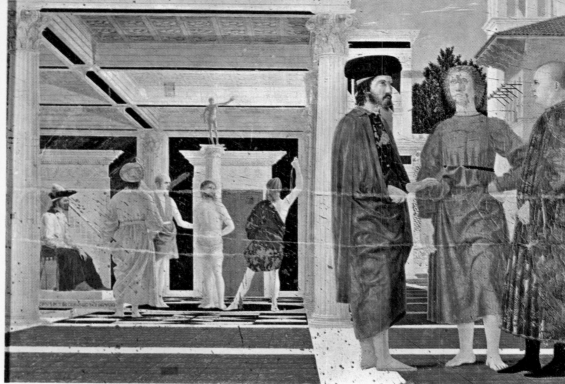

Greece

After a long period of strictly religious art, we first find private art in the form of sculptured portraits *c*. 400 B.C. The favourite subject of Greek art was the human figure which Greek artists studied with passionate devotion. They exploited its potential beauty and harmony with such genius that even today the proportions they worked out have become part of aesthetic dogma.

Medieval Europe

In this period private art was once again neglected. The representation of the human form was considered evil, and the only figures allowed were religious. At this time too—history repeating itself—certain conventions had to be respected. The most characteristic subjects are to be found in Romanesque art.

Italian art—the Renaissance

The first portraits begin to appear in the fourteenth century ('trecento'). They were invariably inspired by a religious theme. The donor of a pious work, for example, would be portrayed in the act of giving.

In this roundabout way the complete liberation of art is achieved during the fifteenth century ('quattrocento'). We can find decisive examples in Florentine art of this time.

The Renaissance begins, a movement which took its name from the return to Antiquity, as if the Middle Ages had been a parenthesis. We note a preoccupation with mythology and subjects tending to re-evaluate the beauty of the human body.

Soon the variety of subjects becomes unlimited. We see the beginning of a love of rules and the most descriptive realism. Perspective is developed and forms the basis of every work of art. Religious themes are viewed with a new freedom, and paintings acquire an air of grandeur and technical perfection.

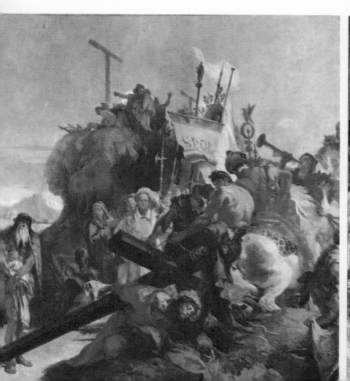

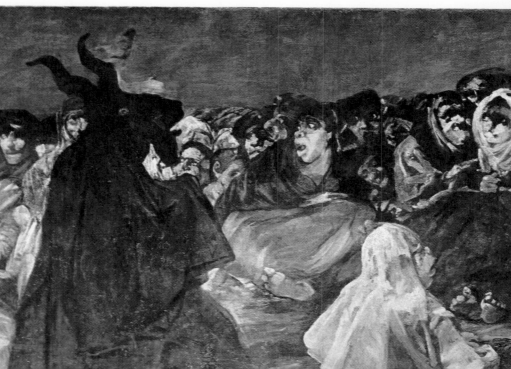

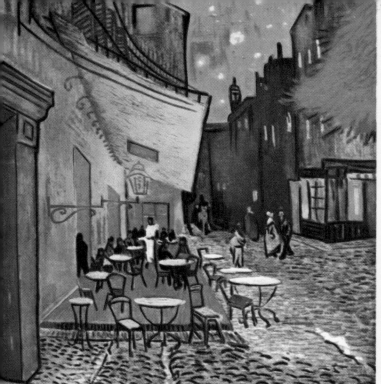

Impressionism

In the nineteenth century, in reaction to the elegance and extravagant romanticism of the previous period, new movements arose which broke with past tradition. The prejudice against certain subjects disappeared and thus anything could become the subject for a picture, even the most commonplace item in everyday life.

Impressionism came into its own as the dominant movement and foundation-stone of modern painting.

Abstract art

Present-day art has once again changed its subjects. Abstract art represents the maximum of freedom of expression. Many believe it to be an art without a subject, but it is not exactly that. The subject is there, but its nature is different.

Today, a bird's-eye view of a city, an object through the microscope, a ruined wall, a light-effect and so on can inspire the painter. The individualization of these subjects is more difficult, not to say impossible; but the artist has discovered—and it needed discovering—that there is beauty in everything, even in the quality of the paint itself. Meaning does not enter into it; what matters is the effect. Just as with music that pleases us without our knowing what it signifies.

Techniques

It's fine to discuss art and subjects, how to interpret them and what we should express, provided we remember that the last two operations require our hands and the right tools in them. We need techniques. Without them the work cannot be executed.

Each individual, according to his temperament, will adopt the technique most suited to his aesthetic impulses.

Before proceeding to the analysis of each technique, we should first make a distinction between the three major groups, each group representing a means of expression rather than a technical activity.

These major groups are:

The techniques of drawing Some prefer drawing because they have a particular feeling for forms, harmony of line and grace of movement.

The techniques involving colour Others, however, are more sensitive to colour, tonal contrasts, the sense of light. They do not like drawing and hence they do not even attempt it. They plunge straight into colour and succeed in expressing themselves better in this medium.

Three-dimensional techniques Lastly there are people who are neither sensitive to drawing nor to colour but are only eager to feel a three-dimensional object in their hands, as if to say, 'This is my reality.'

To which of these three groups do you think you belong? In case of doubt, let us examine all three.

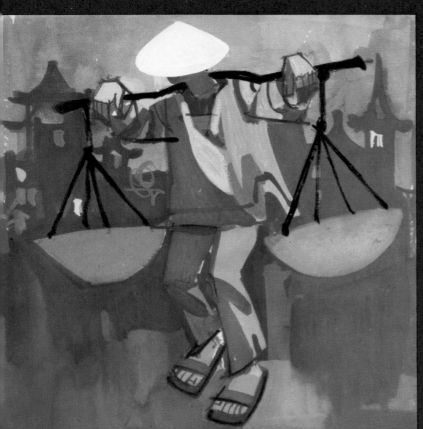

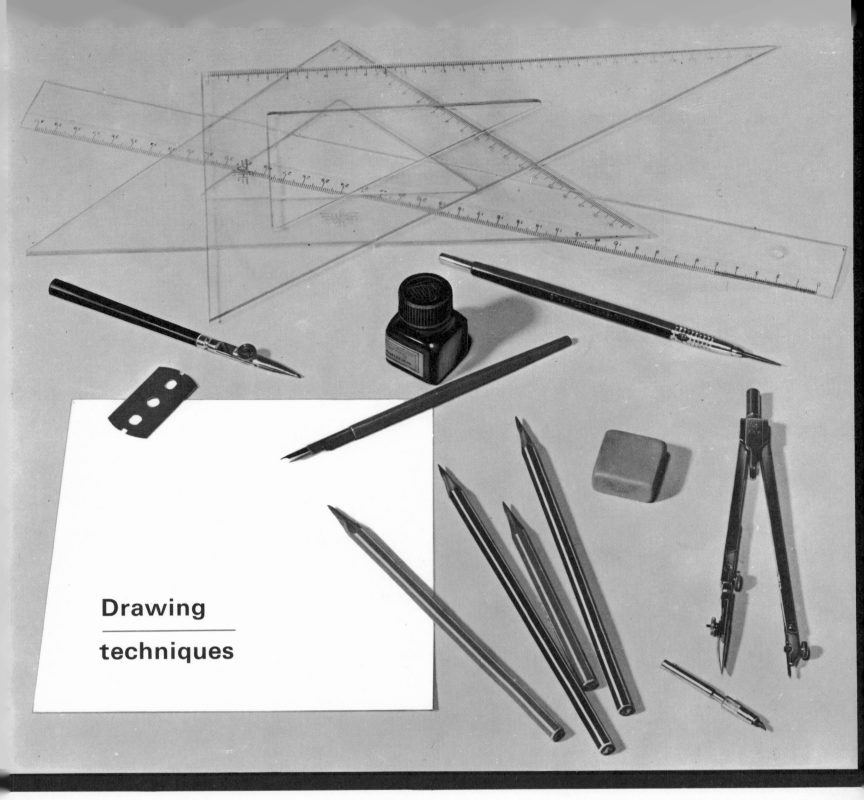

Drawing
techniques

Drawing is as it were the first step. It represents form, line, content. Without line, painting, sculpture and architecture could hardly be carried out.

However, drawing is not always limited to this, shall we say, preparatory rôle. It is often an art in its own right. The need for selection and artistic stylization imposed by this technique is, when properly exploited, the basis of a forceful and genuine art.

According to your own inclinations, you can choose from three types of techniques—all attractive and interesting—which kind of device to employ:

Soft strokes, which permit a maximum value of light and shade ('chiaroscuro') and a rich range of gradation.

Hard strokes, more suitable for the person who is anxious to develop his gift for synthesis and is able to view each subject in terms of line and movement.

Mechanical drawing, for well-ordered minds with a special feeling for decoration, or as the indispensable basis for future architectural studies.

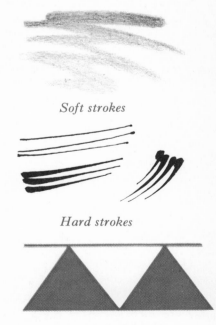

Soft strokes

Hard strokes

Mechanical drawing

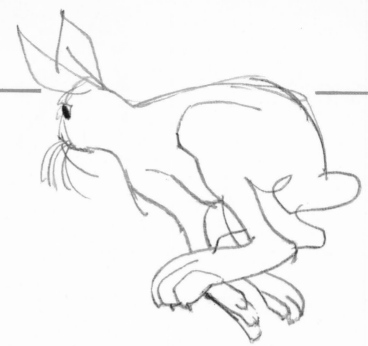

We are so accustomed to using the pencil that we are under the impression that we don't need any lessons on how to use it. But the pencil provides a genuine technique capable of many variations. Demanding as it does absolute cleanness of line which requires considerable skill and practice, it is not as easy as it looks.

We shall divide this technique into three groups:

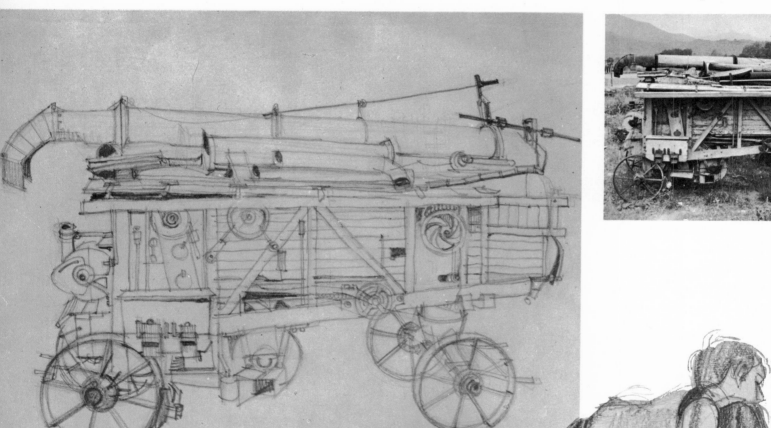

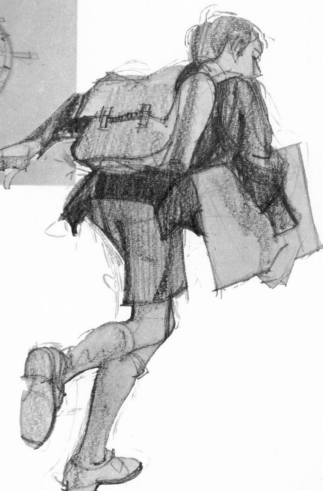

The sketch requires a firm, simple line, stark but unambiguous. Its attraction lies in the quality of line. Subjects in motion or in some way particularly expressive are the most suitable.

The descriptive drawing requires a good sense of observation, and the exploitation of all the details of an idea in what might be described as an almost fussy manner. The most suitable subjects are mechanical or architectural.

The tonal drawing requires less skill but more work. It involves light and shade and gains consequently in effect. All subjects lend themselves to this, especially people and animals.

Three ways of holding a pencil

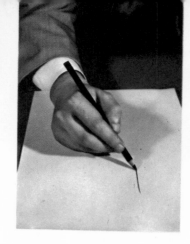
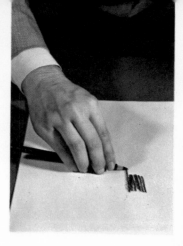

Each pencil technique requires its own hold. The differences between the various results are so subtle that a simple change of position will help you to obtain the stroke needed for each subject.

Three different pencil holds were used respectively for the examples on the facing page: No. 1 for the hare, No. 2 for the agricultural machine, No. 3 for the schoolboy.

Position No. 1 *Hold the pencil at the top, using it more or less as you would use a piece of chalk on a blackboard. This hold allows freedom of movement but demands a degree of manual dexterity.*

Position No. 2 *This hold gives you the maximum control. It is similar to that adopted for writing. Use it for small details or for rather exact types of drawing.*

Position No. 3 *This is very useful for light and shade and for obtaining uniform tones of grey and for broad strokes. The pencil should be held so as to allow the point to move in a horizontal plane.*

Coloured pencils

If we add strokes in colour to the various pencil strokes mentioned, our range of possibilities is increased. This technique is wrongly considered childish. It can produce the most attractive results. The secret lies in the progressive building up of strokes, starting from those in the lowest tones.

Study the example on this page. Note the first stage of the drawing which already shows simple tonal gradations. Gradually other colours are added to bring them all to their final density. The important thing is to watch the slope of the lines which as far as possible should be uniform and preferably made in a downward direction.

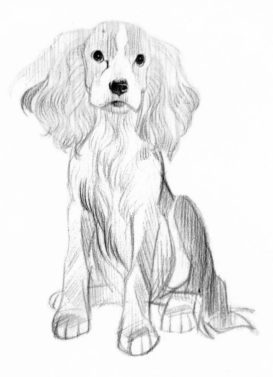

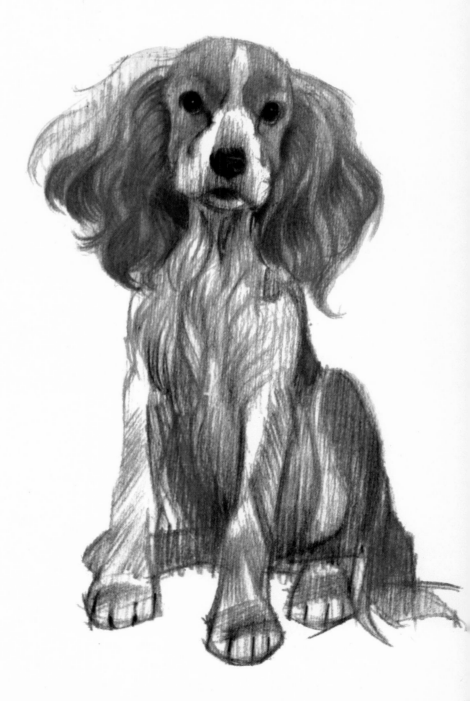

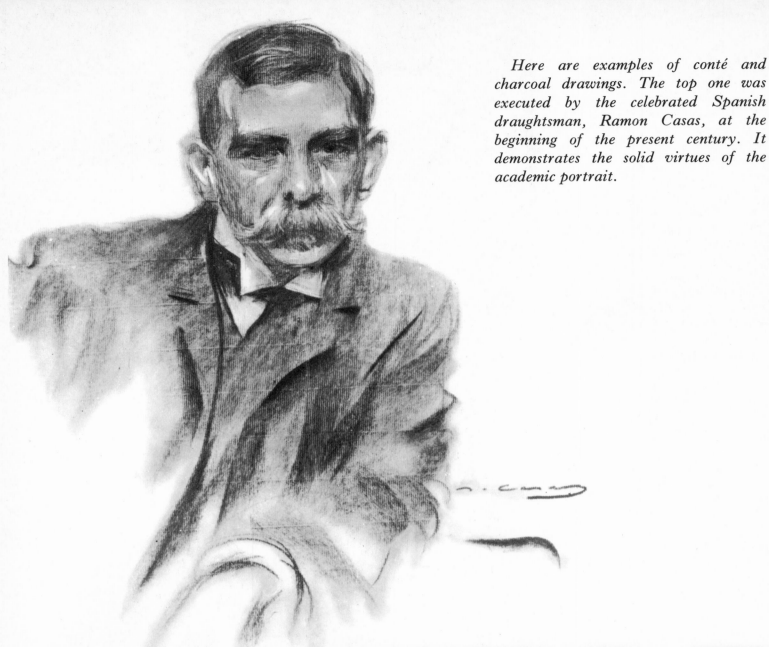

Here are examples of conté and charcoal drawings. The top one was executed by the celebrated Spanish draughtsman, Ramon Casas, at the beginning of the present century. It demonstrates the solid virtues of the academic portrait.

The other example Au concert Européen by Georges Seurat reveals other expressive possibilities of the black chalk and conté medium. Here the pointillist painter has given us a master-piece of chiaroscuro. The bright gas-globes against the gradated grey background, contrasted with the velvety black of the bass-player in the foreground, lend this work a vibrant vitality.

The top example can be admired in the Museum of Modern Art, Barcelona, the other in the Municipal Museum, Amsterdam.

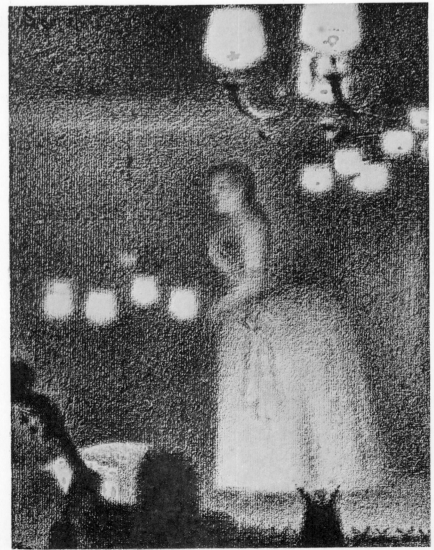

PEN TECHNIQUES

There is a general idea that a pen and ink drawing merely consists of inking-in a drawing already done in pencil. This is not so. The pencil gives scope for tonal shading which—black though it is—is not possible in Indian ink. Therein lies its fascination. It obliges us to synthesize, give every line its maximum expression, build up the grey tones, consider the visual effect rather than reality.

But what attractive results and how decorative! It is a technique well worth while developing because, properly learnt, it will give you great satisfaction.

You may be a little timid at first. You have to gain confidence, and so we begin by demonstrating a few examples, showing how to build up all the various half-tones which, as you see, are considerable.

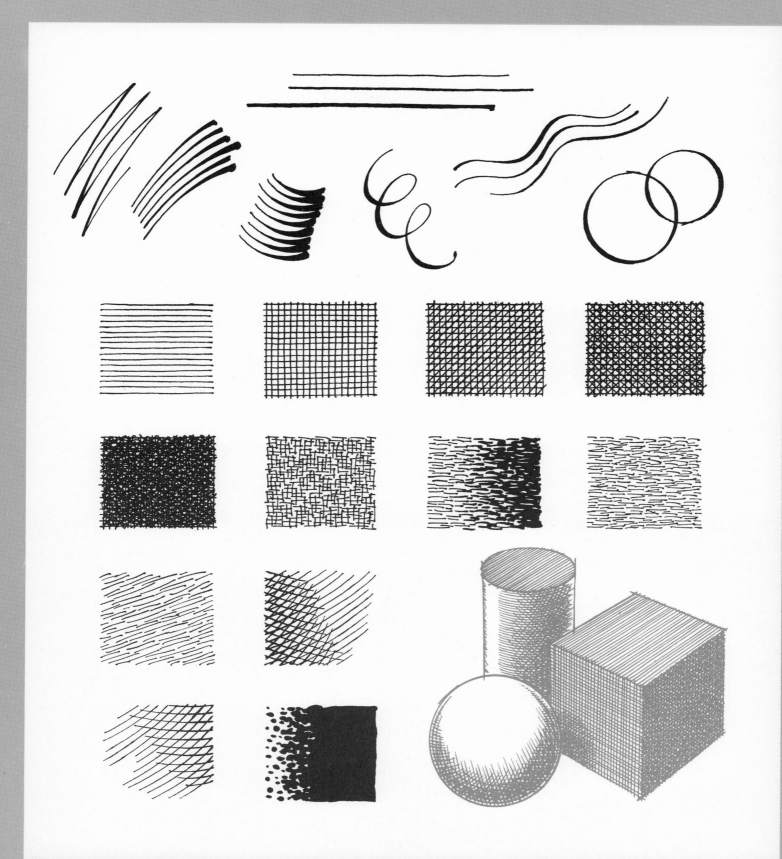

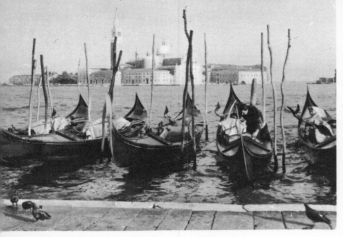

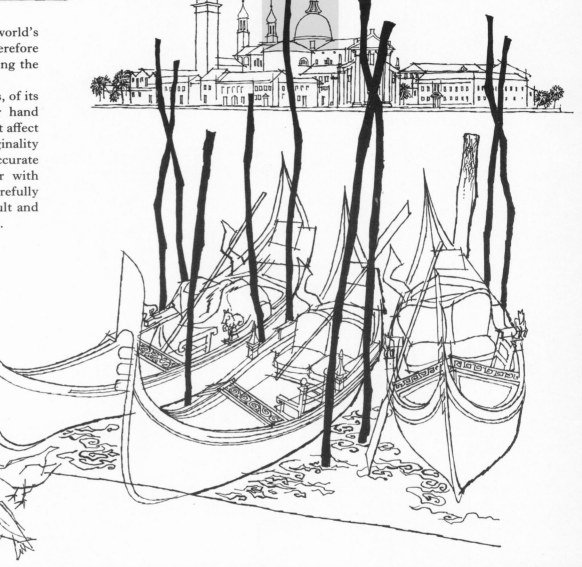

Venice is certainly one of the world's most beautiful cities. We cannot therefore find a better subject for demonstrating the techniques of stylization.

The style most suited to the pen is, of its nature, linear. You may find your hand shakes to start with, but this need not affect your wrist and may even confer originality on your work. Begin with an accurate pencil drawing which you go over with 'broken' pen strokes slowly and carefully (see enlarged detail). It is not difficult and you can obtain very attractive effects.

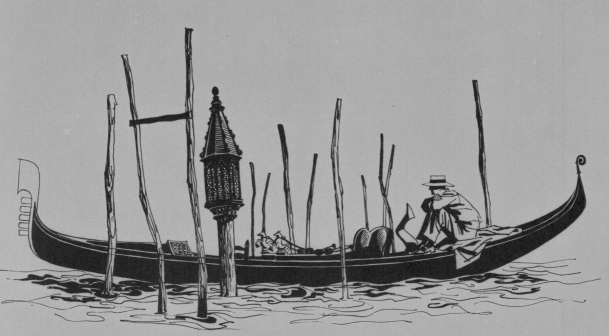

Another very attractive style is the impressionistic in which halftones are avoided. You won't find it difficult. When you are faced with something grey and wonder whether to make it black or white, choose the latter if the tone is light, black if it is a dark grey. Be careful to avoid the juxtaposition of two blacks.

While we are dealing with pen and ink we should not neglect silhouettes—one of the easiest and most effective techniques. Any subject can be attractive so long as the drawing has been skilfully stylized. The sole proviso is that no form should get involved with another, thus producing a confused result. Otherwise, the only hint is to avoid heavy, uncharacteristic shapes. You can achieve quite surprising effects.

Once the outline is made, you should develop it, using the pen to thicken the lines and the brush for larger areas.

Venice has always been a tempting subject for painters (not to mention photographers) of all nationalities. However, as always happens, those who have captured the spirit and beauty of the city best have been the local artists. Among these, Canaletto and the Guardi brothers stand in a class apart.

It is curious to notice how, except in certain aspects of costume, the Venice of these pictures still remains the Venice of today, eternal Venice which, oddly enough, has not changed with the centuries.

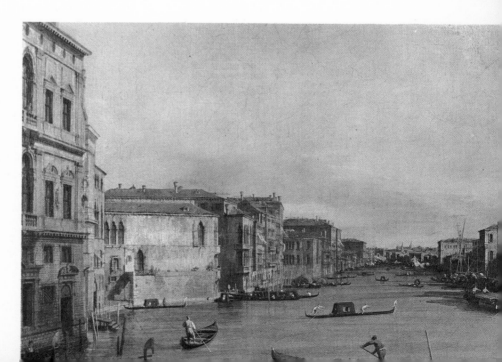

1

You have learned the techniques which we can call 'outlines'. Now you must forget this beginning; indeed outlines are now banned. You must think of areas, of 'planes'; in a word, we are proceeding to the techniques of chiaroscuro (light and shade) for which the exercises on p. 17 will prove useful.

For this technique you must start from a pencil drawing, making full use of 'values', i.e. all the tones of grey (fig. 1), after which you will begin by replacing every grey pencil surface with pen-strokes that approximate to the grey—but dispensing with a surrounding line. You begin with the darkest zones and proceed to the lightest in a series of gradations. The deep black should be applied first (fig. 2).

Now look at the completed drawing. If the hatching has a grey effect when viewed from a distance your drawing is successful.

Note the almost complete absence of contour between one tone and another, and the difference of intensity which determines the separation of the planes. It is true that some lines remain, but solely for the purpose of defining those small or secondary details which do not constitute real planes (fig. 3).

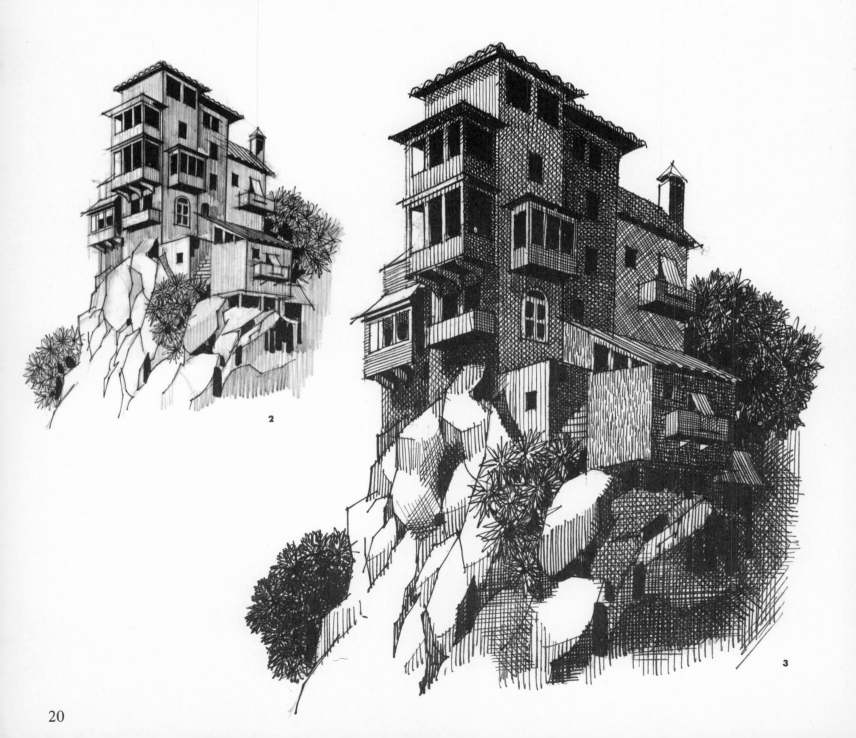

2

3

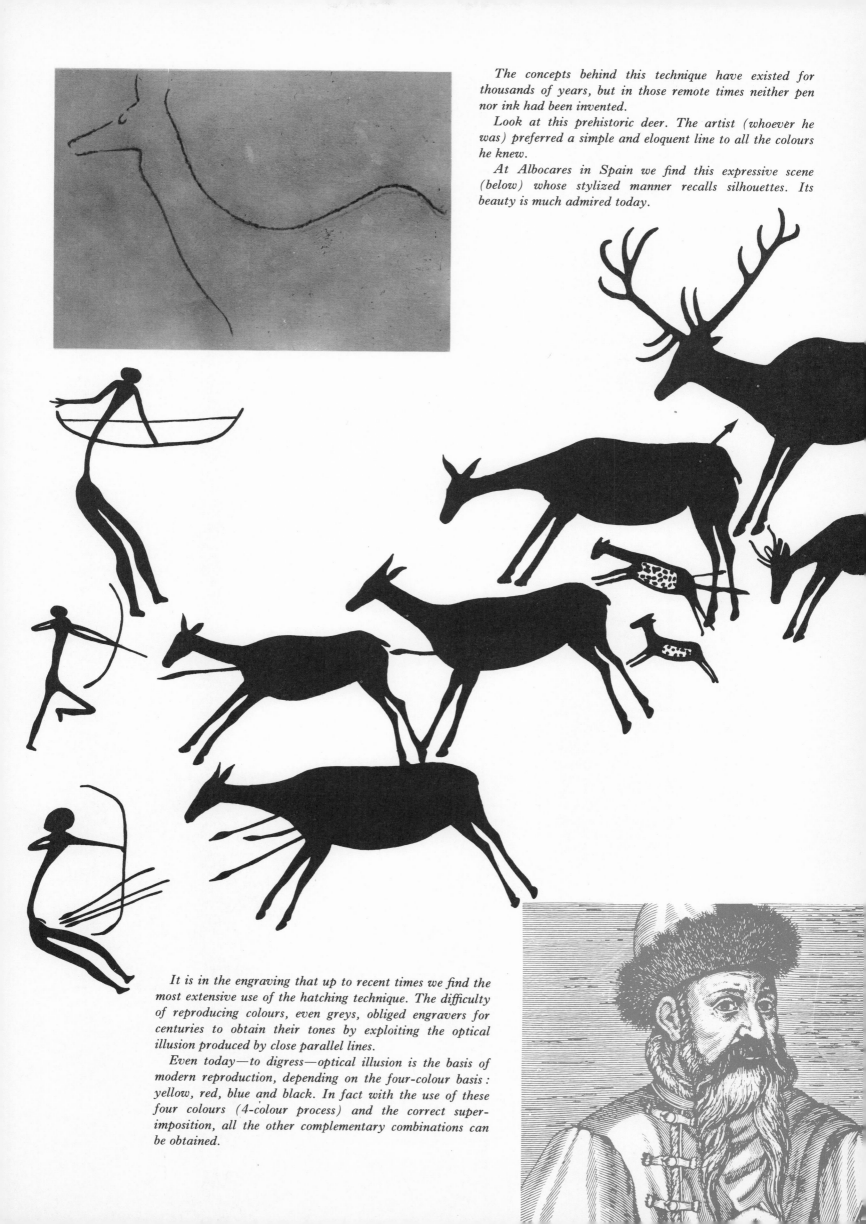

The concepts behind this technique have existed for thousands of years, but in those remote times neither pen nor ink had been invented.

Look at this prehistoric deer. The artist (whoever he was) preferred a simple and eloquent line to all the colours he knew.

At Albocares in Spain we find this expressive scene (below) whose stylized manner recalls silhouettes. Its beauty is much admired today.

It is in the engraving that up to recent times we find the most extensive use of the hatching technique. The difficulty of reproducing colours, even greys, obliged engravers for centuries to obtain their tones by exploiting the optical illusion produced by close parallel lines.

Even today—to digress—optical illusion is the basis of modern reproduction, depending on the four-colour basis: yellow, red, blue and black. In fact with the use of these four colours (4-colour process) and the correct super-imposition, all the other complementary combinations can be obtained.

MECHANICAL DRAWING

A certain misunderstanding exists concerning this type of drawing, namely that such work done with the aid of ruler, compasses etc. merely serves for the execution of plans or for mechanical drawing. This is not nor has ever been the case, for this type of drawing has been used for decorative, that is, aesthetic purposes since time immemorial. It is true that the apprentice stage is a little uninspiring, but once you have mastered the basic principles, imagination should take over.

Practise hard then, ruler in hand, and aim at precision but without undue haste. The results by this technique are either success or failure—there's no half-way.

1. **Ruler exercises** *You will have to draw lots of parallel lines before you gain mastery over this instrument. All the lines should be equidistant and of the same density.*

2. **Method of working** *As the above diagram indicates, the set-square is indispensable. The first geometric drawing will be the construction of a square.*

3–4. **Hexagon and pentagon** *These figures recur constantly in geometrical decoration. Their execution must be faultless.*

5–6. **Scope for ingenuity** *Here are two examples of pure decoration. You will note that it is more a problem of ingenuity than technique (which, however, you must be familiar with). The type of colour to be used in conjunction with ruler and compasses is gouache (poster paint), applied moist with a fine brush.*

7. **Meander** *A very useful ornament for framing certain kinds of work. You can invent an infinite number of similar repeat patterns.*

8. **Oval** *A useful geometric form, drawn entirely with compasses. Try it.*

9. **Compass doodles** *Don't be content with copying this pattern. This instrument offers countless potential designs. Go ahead!*

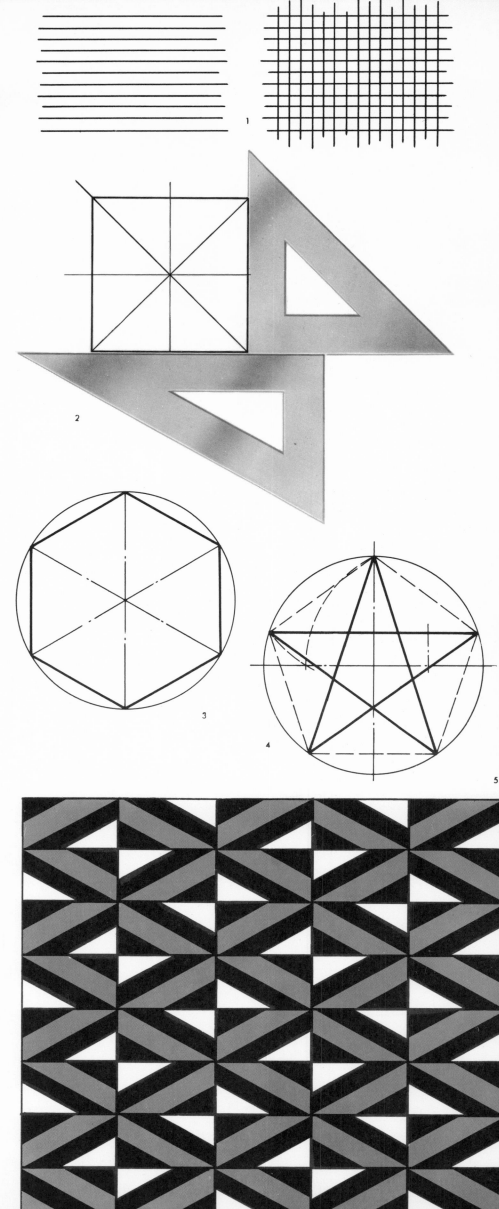

7

6

8

9

Antiquity has bequeathed us many fine geometrical designs, mostly in the form of mosaics or architectural decoration.

The Arabs, past masters in filigree work, have produced and continue to produce real masterpieces of taste and perfection in their workshops.

This is a detail of the Alhambra, Granada, Spain, built by the Moors 1238–1354.

10

11

10–11. **Colour** *Now you can give free rein to your imagination. Before attempting pictures in colour, practise using body colour (gouache) in conjunction with ruler and compasses. We have pointed out that this technique must be based on faultless execution—patience and precision.*

Abstract art has opened the door to geometrically based drawing once more. Mondrian and Klee have been the outstanding exponents of this speciality.

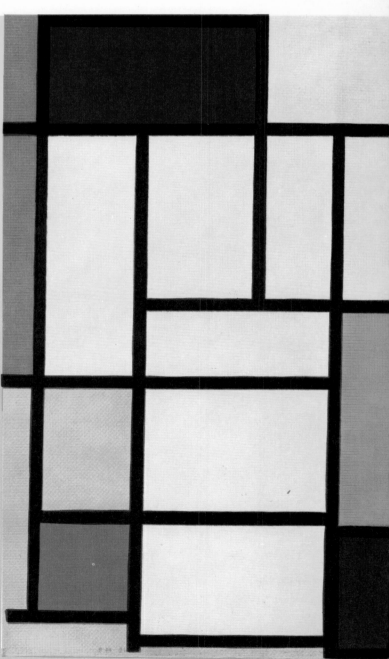

Piet Mondrian:
Composition in red, yellow and blue

Paul Klee: *Open book*

Colour
techniques

Of all the arts painting offers the greatest artistic possibilities and is doubtless the most representative of the fine arts. Apart from its expressivity of form, painting gains from the vast resources of colour. Colour influences us physically as well as psychologically. Indeed the artist has at his disposal a great expressive force which offers him a real wealth of possibilities and aesthetic experiences.

Three main kinds of colour techniques are available:

Diluted colours (diluents: water or oil).

Dry colours (where gradation depends on the intensity of the stroke).

Applied colours (collage, the effects of which can be assessed before their application).

There are of course many mixed, derived techniques which we will deal with later.

Diluted colour

Dry colour

Applied colour

DILUTED COLOUR

Water-colour. This is the most representative of techniques using water as a diluent. The colours resulting are subtle and transparent.

The colours are 'added' to one another, or alternatively, the colours of the first application can be modified. They should however never be wholly covered precisely because of their transparency.

Oil. This process is the exact opposite of water-colour since the successive applications of colour cover those that precede. The colours are mixed before applying.

A half-way medium: gouache (body or poster colour). Our first colour experiments will be in this technique. The reason for this choice is that in some way it combines the characteristics of both media—it can be used as a transparent medium (partial), but applied generously it is opaque. Furthermore it dries quickly which ensures an easy and clean application.

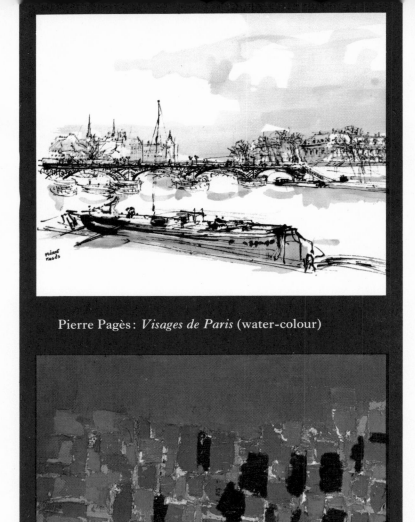

Pierre Pagès: *Visages de Paris* (water-colour)

De Staël: *Roofs* (oil)

How many colours exist?

It is true that there seems a great number but in fact they can be reduced to three: yellow, red, blue. With these three and the help of white and black (which strictly speaking are not colours but represent respectively the maximum light and the absence of light) we can reproduce—as printers well know—all the colours in nature.

So let us try some initial experiments with these three primary colours. In this way you will learn how to extract the maximum effect from your palette. Look at the one on p. 26 and you will see how secondary colours are built up from these primary colours. Black and white merely darken or lighten the original tones.

After this simple experiment we can pass on to exploit the other colours at our disposal, starting out with a richer palette. To the original five (red, yellow, blue, black, white) we can add the following secondary colours: orange, violet, green and brown. As you can see, the range becomes complete and available for any subject whatever colour is involved.

FLAT TINTS

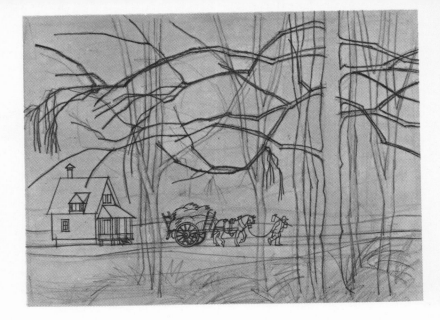

Techniques of diluted colour—and gouache is of course no exception—are not easily controlled unless skilfully handled. Water can play dirty tricks at the most inopportune moments. So let us start with flat tints, a gouache technique but with areas of uniform colour. The result is most effective and the application of colour can be controlled perfectly. Naturally we have to pay the price for this control; it demands discipline, patience and method.

Let us now examine a stage-by-stage development of a subject executed in flat tints.

1. The drawing cannot be done on drawing paper. It must first be drawn on a tracing type paper on which you can rub out or correct without damaging the final sheet.

2. When the drawing is completed, take a soft pencil (2B) and cover the back of the thin paper so as to make a kind of carbon paper. Thus you will be able to transfer the drawing to the final sheet by going over the original drawing with a hard pencil (H). During this tracing process the two sheets of paper should not be allowed to move.

Practical hints

Hint number one is to fix the upper portion of the tracing paper to the drawing-paper. This is best done by making a small fold on the former so that the sticking can be done on the back of the final sheet. Thus when the first part of the picture (corresponding to the background of the subject) is traced, you can fold the tracing paper towards the back of the drawing-paper (like turning back the page of a notebook) so as not to get in your way while you paint. As each stage is completed (once the paint is dry) return the tracing paper to its original position and proceed to trace a nearer plane of the subject and so on.

Another hint is to prepare the main colours beforehand (naturally those of the major colour areas) in different pans; in this way, even if your work is interrupted, you can resume it without having annoying alterations of colour.

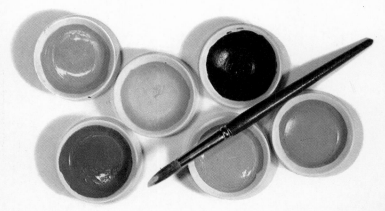

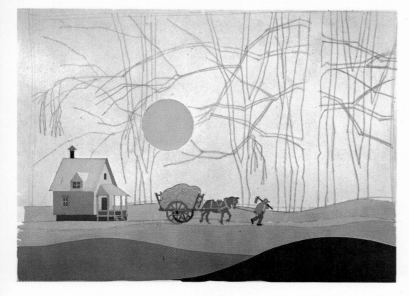

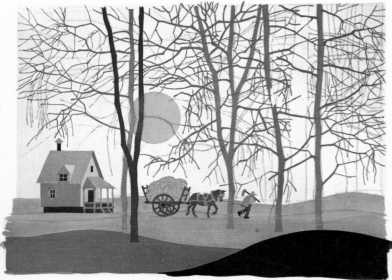

3. It is absolutely essential to paint the most distant planes first. Thus, exploiting the opacity of poster colour, it will be easy to superimpose the foreground elements on them. Colours should be mixed before applying them, and the tones kept uniform and fit exactly within the pencil lines.

4. The distance of our landscape will consist of the house, cart, path and the sun. When these are painted, we can apply the lighter-toned trees of the middle distance.

Remember that poster colour is opaque and it does not matter therefore if there are other (dried) colours under the fresh brush strokes; the last ones will always dominate.

Once the middle distance is completed, we can start on the nearer part with the darker trees.

5. Now the subject is finished, the final application of colour being on the immediate foreground —the dark tree on the right.

Working in this way with a series of superimposed planes you can produce a fascinating result with the minimum risk. It is perhaps a little laborious, but you can't go wrong. Try it.

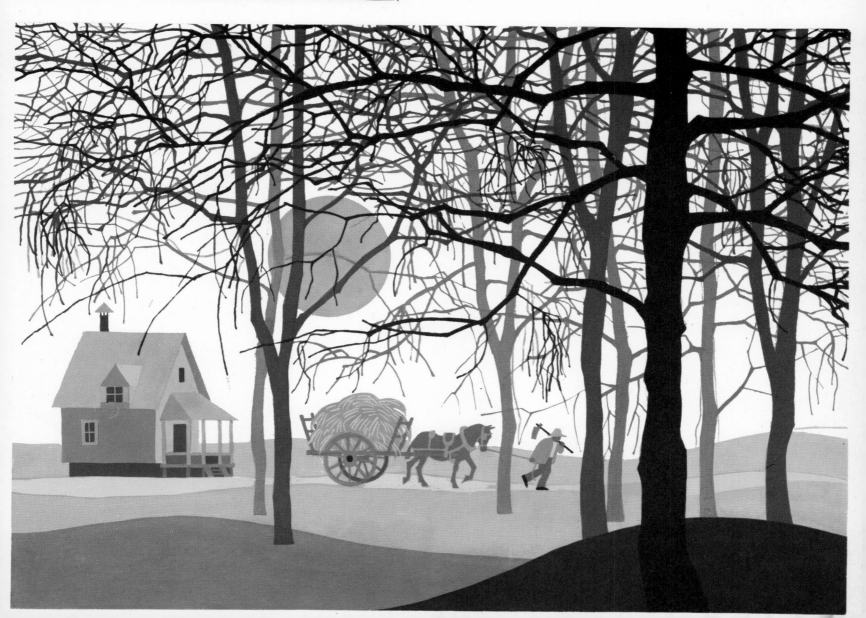

As you will have noticed, this technique does not allow tonal gradations, but it lends itself to the inclusion of lots of detail. That is why it is suitable for explaining a subject so well. Look at the chalk drawing and you can see how appropriate the technique is. Since you are limited to simple tones, you can indulge your fancy in the subject; the flatness of the colours rules out complete realism.

The black background lends a freshness to the picture since it allows you to work with denser and darker colours. In point of fact a colour which looks very dark on a white ground seems much lighter on a dark ground. Many of the colours used

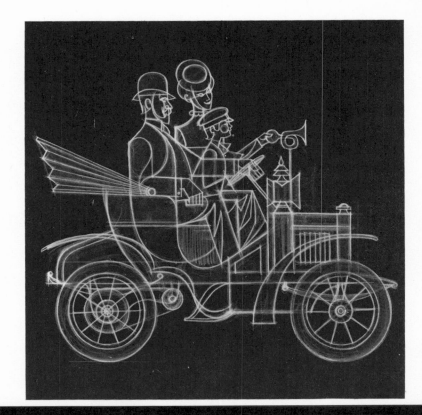

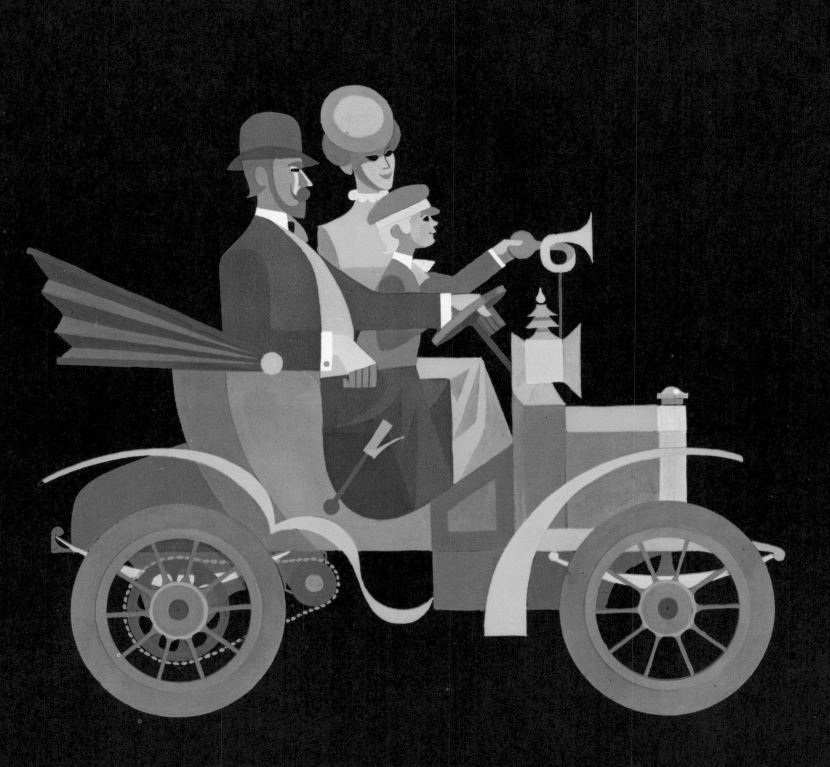

in this example are very dark. To test this, take four strips of white paper and isolate an area of colour (e.g. the man's jacket), framing it with the white strips. You will be struck by how dark the colour looks. The same applies to other colours in the subject (the man's face, the car, the tyres etc.). It is precisely this factor that gives the picture its effectiveness. In contrast the light colours (white, yellow etc.) create an extraordinary luminosity, somewhat dramatic, which you must be careful not to overdo.

Take a sheet of black paper and try the experiment. Any subject will do, but choose one with not too much variation of tone so that it can be represented in this flat-tint technique.

Before beginning however, here is a hint: when you use black paper draw the outline with a white, yellow or orange chalk so that the lines of your drawing will stand out.

You will discover a fund of inspiration for this kind of subject in pictures of the Romanesque and Gothic periods. Their simplicity of expression, their descriptive element, their absence of perspective make them admirable starting-points for your pictures on the same subjects. We give a proof on this page. The picture on the left was inspired by a fragment of a fresco by Lorenzetti, shown below. The title of it is Good Government.

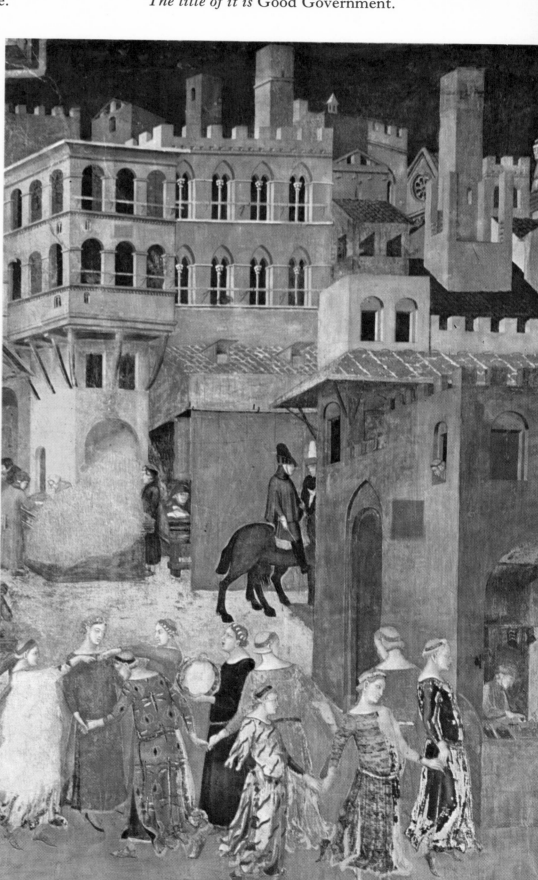

DRY TECHNIQUES

Wax or oil pastels and crayons

Your familiarity with these techniques will certainly go back a very long way. We cannot however neglect to explain them, precisely because of their popularity in schools, though we shall confine ourselves to a few practical hints.

First choose your subject. Pastels do not lend themselves to detailed work. You should choose subjects with great masses of colour, treating them impressionistically rather than in detail.

As a precaution, it is better to begin with low tones so that you can anticipate the general effect and correct possible colour clashes in time. If this initial application of colour has been discreet, the final layers of colour will completely cover those underneath.

Did you remember to leave the blank spaces? There is a white pastel in the box but it should only be used for producing lighter shades; do not put in pure whites on top of other colours. These blank areas must be anticipated (in the subject demonstrated: the high-lights on the apple, tomato and grapes) so that they are left white on the paper.

Protect each drawing by 'fixing' it to avoid smudging. You will be able to buy fixatives in most art shops.

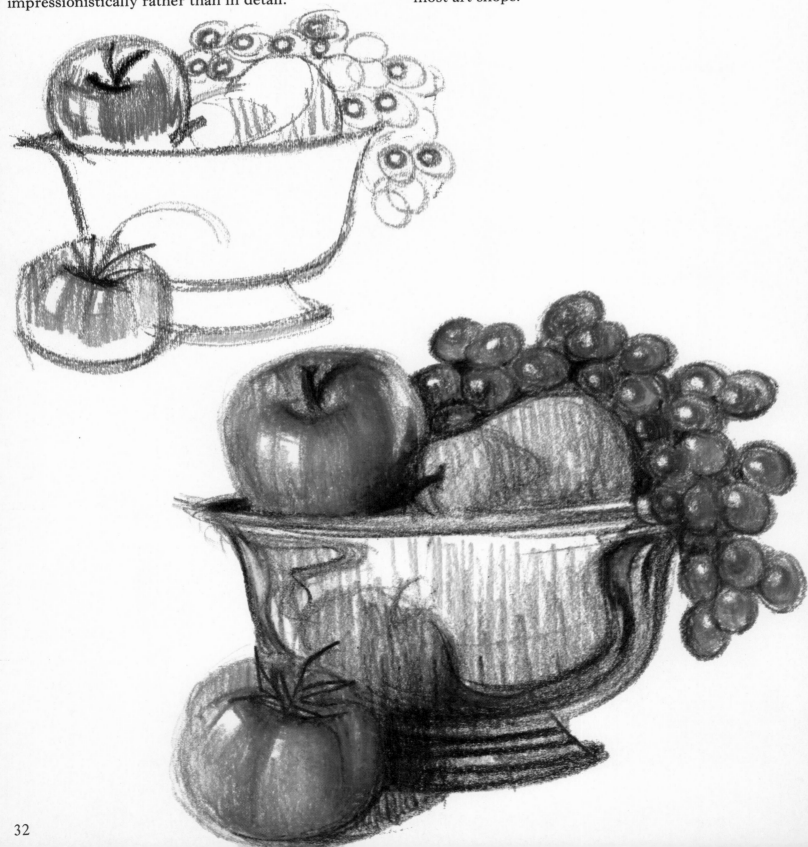

APPLIED COLOUR

Collage

You have to take your courage in both hands to embark on this technique. However, the results produced with it are fascinating and sometimes unexpected. Collage, as you know, consists in fixing strips of coloured paper, previously decided on, to an outlined design. The beauty of this technique lies in the fact that the colours are limited and the cut-out shapes only approximate to reality. These elements of improvization lend great spontaneity to the result.

Coloured papers are generally on sale in stationers' shops and you will have ample choice. But the most interesting, and incidentally the least expensive results can be obtained from other sources of paper—pieces cut out from illustrated magazines containing colour photographic reproductions.

The vignettes on the left show the order in which one applies the different planes. The larger picture was composed however from magazine material which gives it a variety of tones which we could never have obtained by painting them.

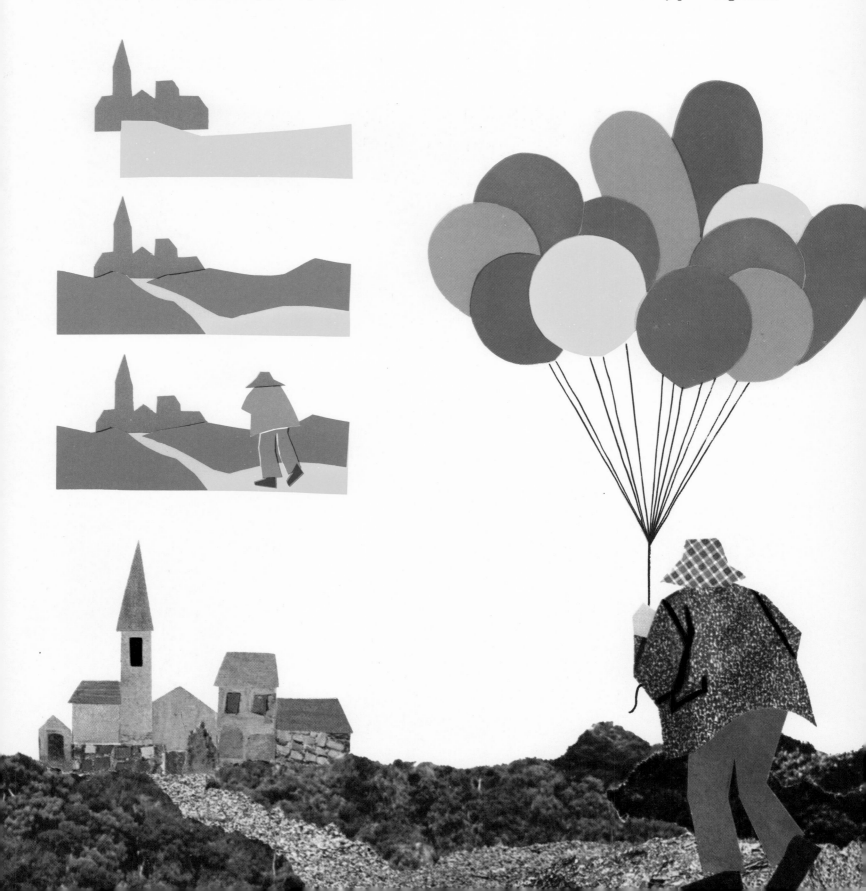

Decoration by removal and transference of colour

We are now going to see a very attractive technique and one that is little known, developed on the single print principle. It consists in the decoration of areas of colour. We have already seen a modest example in the picture of the stone wall on p. 8. Sometimes colour is too uniform, too smooth and fails to explain the material it is meant to represent. So we have to resort to a means of applying direct pressure on to the colour to produce the required variation.

Let us try the first experiments. Take a tube of poster colour, a paint-brush, a piece of drawing-paper and sheets of any thin paper and proceed as follows:

1. Take the thin paper, screw it into a ball. After squeezing it hard unfold it and you will note that it is covered with lots of creases.

2. With poster colour that is neither too liquid nor too thick cover an area of the drawing-paper using a thick brush.

3. Before allowing the paint to dry, take the creased paper and apply it to the painted area, making sure that you do not move the paper while placing it in contact with the damp colour underneath. Now press on the whole surface so that the contact is complete.

4. Now carefully but deliberately take off the thin paper, which will of course remove a little colour from the sheet underneath.

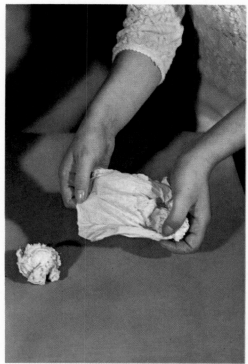

1

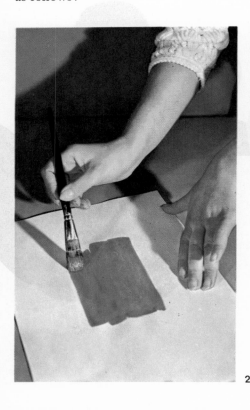

2

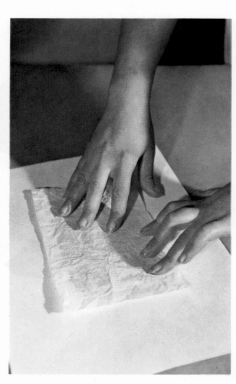

3

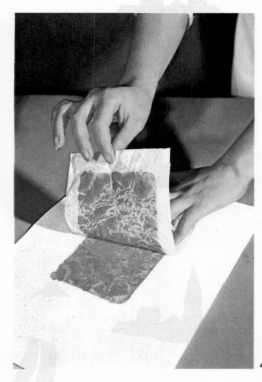

4

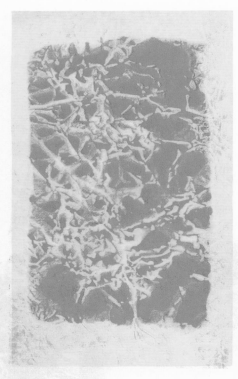

5

5. Here is the first result. The thin paper with its creases will have lifted part of the colour that you applied to the drawing-paper. We will call this result a 'transfer'. Pieces of paper decorated in this way can be used to compose interesting examples of collage.

6. Another result, interesting in a different way, has been simultaneously produced on the lower piece of paper. The painted area has been decorated by the 'removal' of colour. This result will be very useful for adding interest and attraction to colour areas in a poster-colour painting.

6

Now let us look at a series of experiments using this process.

1. The first illustration results from the procedure already explained; crumpled tissue paper was used. The result is an irregular kind of arabesque.

2. If other materials are employed for the removal of colour, the result will obviously be different. This, for example, was obtained by using a piece of fabric.

3. When using similar pieces of tissue paper various transfers are carried out and in conjunction with different colours, the result is enriched with new—and always unforeseen—tonal effects.

4. This result can be produced with the reverse process. But we will need a coloured paper for support. These monoprints on glossy paper are the best because the colour dries slowly on them.

5–6. However, the most effective result is always obtained against a black ground. You only need look at the two examples at the bottom of this page to be convinced.

If you decorate papers in this way you will have a supply of resources for collage ready for the production of original designs.

1

2

5–6

Here is an attractive result obtained by using the two resources of this technique. On the one hand we have decorated certain colour areas of the picture by removal; on the other we have utilized the cut-out pieces of thin paper with transferred colour to complete the collage. You will have no difficulty in observing these in this work. Look at it more carefully and you will discover one by one all the resources exploited. Don't forget that the techniques can be mixed and even used in opposition. What really counts is the ultimate result.

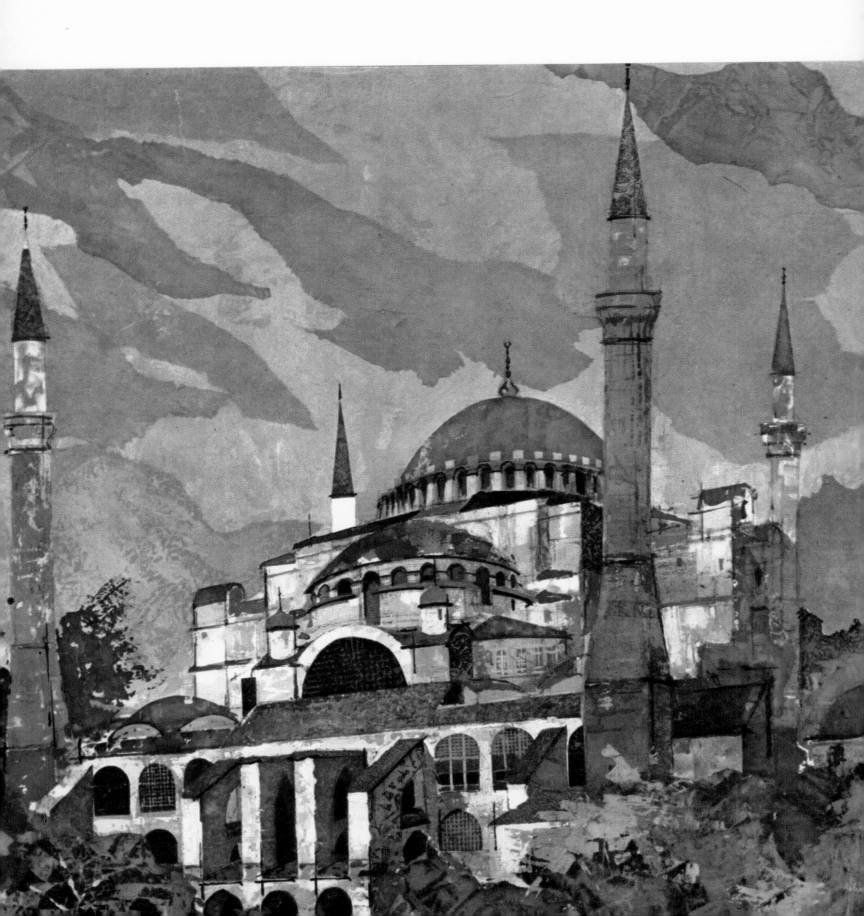

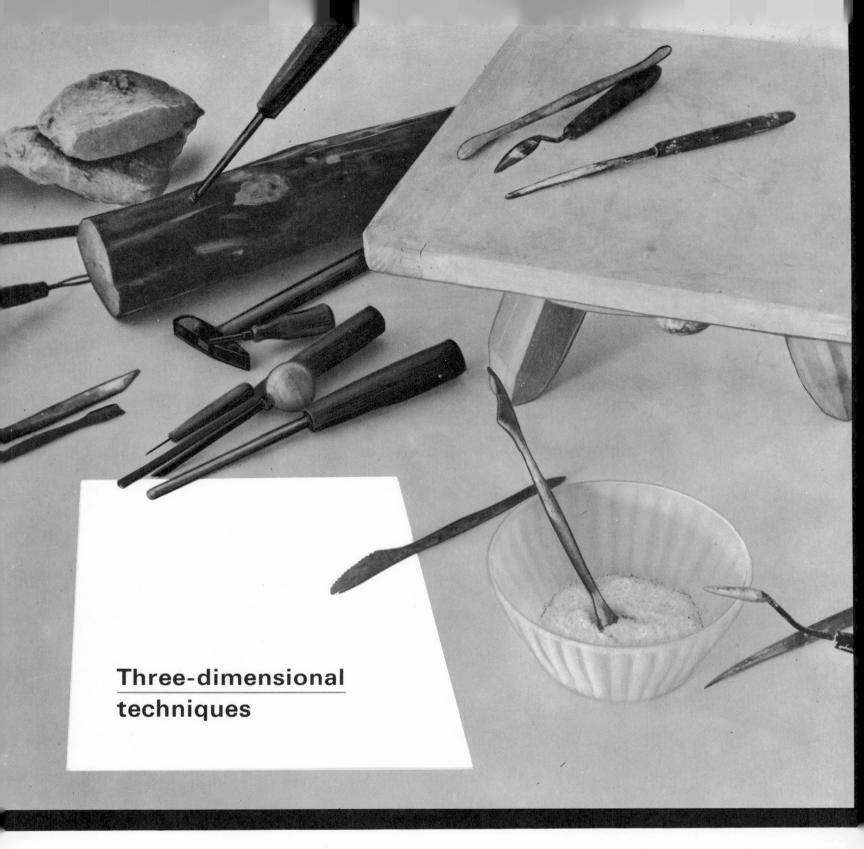

Three-dimensional techniques

The use of a solid material to reproduce natural volumes is one of the most varied and fascinating branches of art: sculpture.

It is true that it requires special working conditions; the pencil and paper used for drawing will no longer suffice. It involves some equipment and preparation but in the end it proves well worth the effort.

Sculpture can be carried out in a variety of materials: iron, bronze, marble, clay, wood etc. But, in effect, there are two basic techniques for sculpture:

The technique of modelling in malleable materials which allow us to mould them into the form desired.

The technique of carving, consisting of clearing away hard matter with tools to extract the final form.

The technique most often employed in art classes is that of modelling, being quicker and more convenient.

Modelling

Carving

MODELLING TECHNIQUES

Clay

Any modelling you have done so far may well have been in plasticine, but as we are now dealing with sculpture, it will be better to start with a more professional material. In any case we should not linger too long on the technique and even less on the material used. What is more important at present is to understand the mechanics of volume and to acquire a sculptural vision of things.

For the moment, let us pass on and see how modelling clay is used. It is merely clay which, washed and suitably treated, possesses great plasticity. This allows it to be worked into any shape. As it dries, it hardens and remains firm. Unless the clay is baked at a high temperature, even after a certain period of time when it is dry, it will become soft on contact with water and can be used again.

Clay ready prepared is sold in special plastic bags at potteries and art-dealers.

The three stages of the work

In all kinds of art processes there are three stages:
- **The choice of subject**
- **Stylization or creative process**
- **Realization**

Sculpture is obviously no exception. Some people have the idea that modelling merely consists in taking the clay and beginning to shape the figures. This is not so. Before embarking on the work, you need to know what exactly you want to do and how you intend to do it. The preliminary stages can be carried out in your head or you can make use of pencil and paper. It is a matter of individual choice. The important thing is that this creative preparation cannot be neglected. No work comes off without such study.

You will find this creative process illustrated in the examples that follow. The whole procedure is not always necessary, but if it is carried out, you will more readily grasp the mechanics of stylization.

Pick up the clay then and prepare to start. Don't worry, we are choosing easy and appealing subjects.

The importance of research

Sometimes one hears people denying that they copy and claiming that they invent their subjects. This is not true, because we all copy. No one could invent a frog or a parrot if he had not already seen them. In any case he would be copying from memory.

Even if you do the working out in your head, it is better to document yourself on whatever you hope to produce. But this does not imply total copying. It means getting your inspiration from real life and then creating your own work.

Let us take a practical example. Suppose we plan two modest sculptures. We begin by doing some research on the subjects chosen. For this books or magazines will be of great assistance. Sometimes a single photograph is not sufficient to clarify the forms and characteristics of the subjects, so it does no harm to seek out the maximum amount of visual information on the theme.

For the present experiment we have chosen a parrot and a frog, two strongly individualized creatures, precisely because they lend themselves so well to stylized treatment.

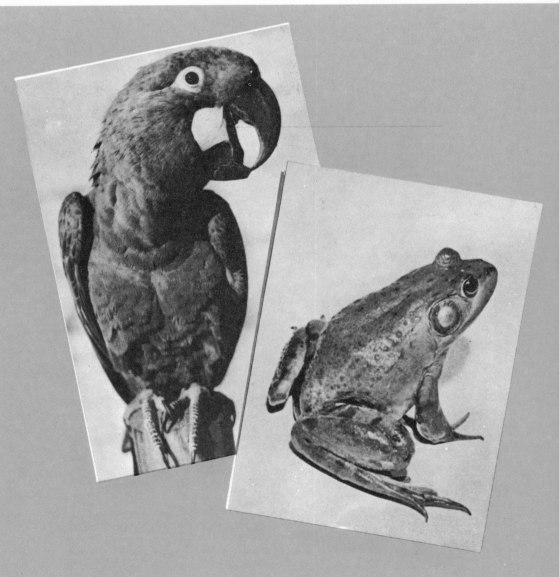

Stylization

The realization

In order to produce a sculpture you must above all understand the forms, how the various volumes are composed, what is of primary and what of secondary importance, what is the most interesting and harmoniously attractive pose. Let us see how this mental process works:

1. Here are the principal forms, already somewhat simplified but still too realistic.

2. Here we are beginning to proceed as a sculptor would. The blocks which make up the subject are mentally separated: body, wings, head and neck, claws ... items in slight relief are eliminated.

3. We are now approaching complete stylization: a minimum of elements, simplicity of line, balanced forms ... It is important that the parrot should not lose his salient features.

4. Now for the creation. Departure from reality, idealization of the form. We must be careful to stop in time or we may eliminate the subject altogether!

No one could now accuse us of copying a photograph.

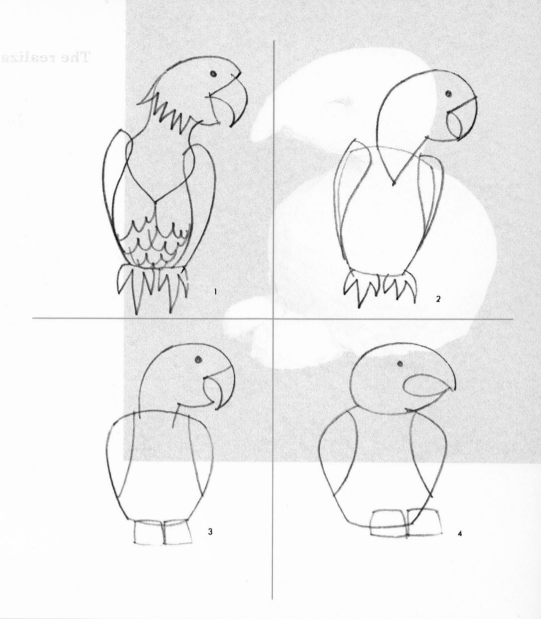

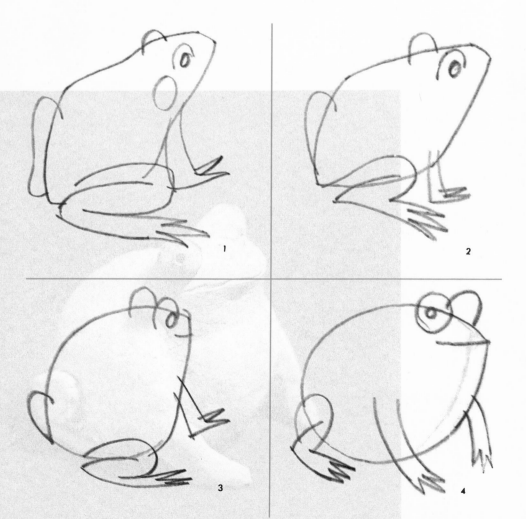

We apply the same criterion to the frog. As in the preceding example, what matters most is to reduce the forms to their essential shape, retaining only those volumes which characterize and define the subject. When it comes down to it, what is a parrot? A curved beak. And a frog? A little ball with eyes and legs. That is all we want. The other details are relatively unimportant.

Here is the creative evolution of the frog:

1. Form inspired by reality, indispensable stage for the understanding of the form.

2. Preliminary study of the volumes or basic elements.

3. Selection of the characteristic forms for the exaggeration of the main volumes.

4. Final idealization. The subject is reduced to a ball, two small front legs, two jointed back legs and two huge protruding eyes.

Neither more nor less than what is wanted.

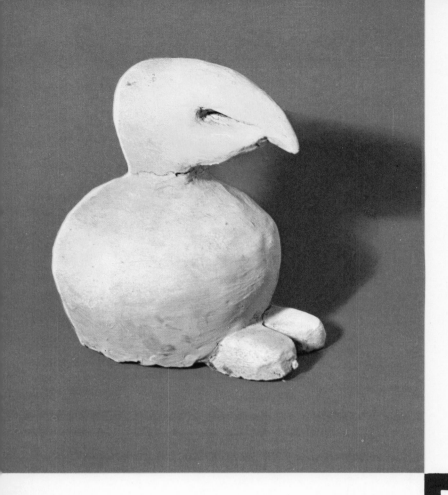

The realization

We have already got a mental picture of the form we want to give our parrot. Now we must prepare the clay and the tools—very few for this little experiment—and start our work.

The subject is composed of three parts: head, body and legs. It is essential to begin with the body since that must be the centre of the construction. Then we will add the head and finally the legs.

Once everything is in its place, our next task is the modelling and finishing which, in principle, will give the work its character. This done, we shall have to wait until the clay is dried out. Then we will continue.

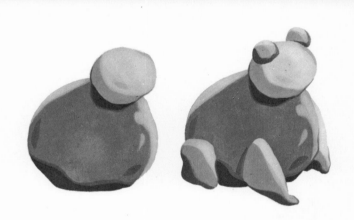

We pass on to the second model. Here too the main part consists of the body. For this we need to model a ball of clay. To it we shall add a half-sphere to make the head, squeezing it and joining it to the body so that it becomes an object in relief upon the latter.

We shall make the legs separately and attach them to the body, using a spatula to smooth over the joins. Finally we will place the two clay pellets for the eyes.

The works needs an accurate finish so that the parts, independent at first, are integrated into the whole. A final line will indicate the large mouth and two well-placed holes provide the finishing touch for the eyes.

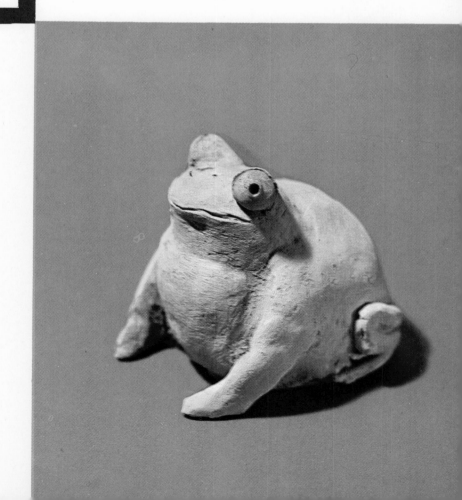

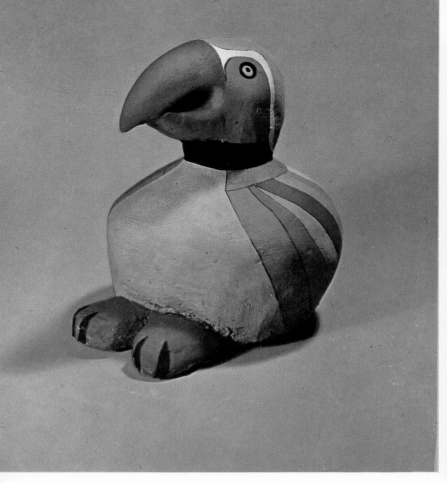

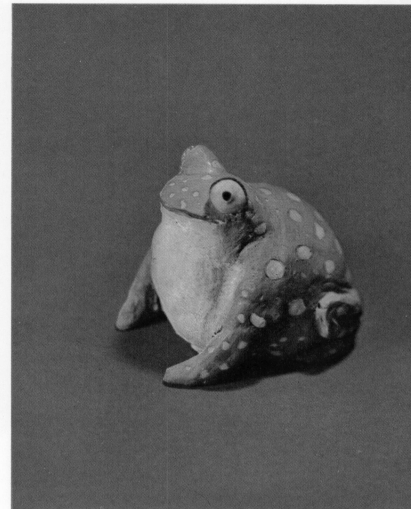

The colouring

Should pieces of sculpture always be painted? The answer is 'no', or rather 'not necessarily'. In the present case it is better to paint them since their simplicity and characteristic colour—especially in the case of the parrot—permits of greater expressiveness.

All you need to do before proceeding with colour is to give them a coat of white paint to render the clay impervious to the poster colour which we then apply.

Colouring should be free no less than form. The final effect of the work will depend on such freedom.

Here is an example of painted ceramic that dates back to Pre-Columbian civilization. Without the decoration the form would lack some of its attraction.

Experiment yourself with some simple objects. You will find it very satisfying.

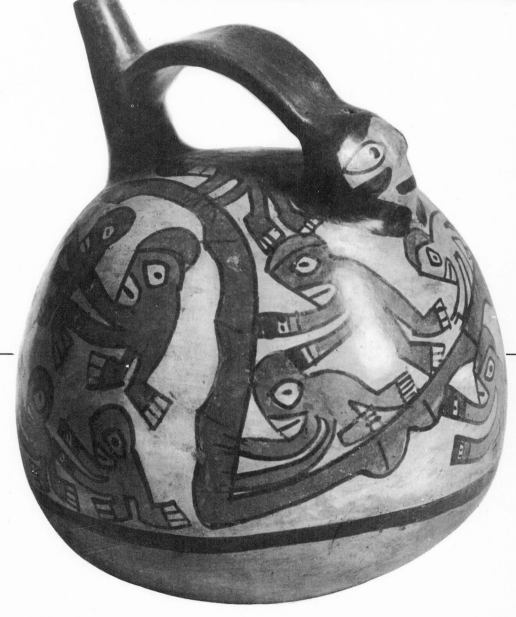

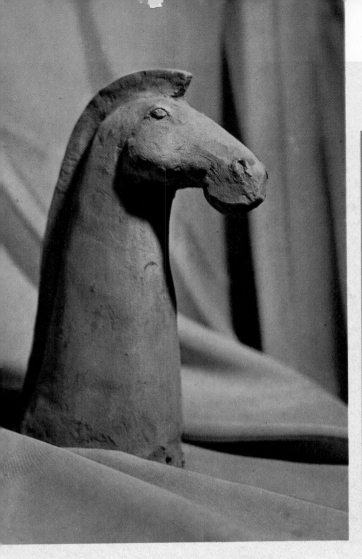

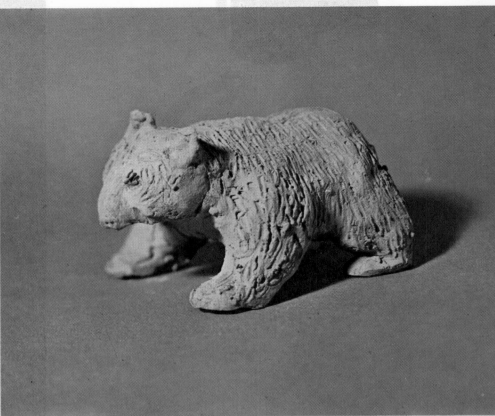

This page shows examples, by way of contrast, for which colour was not essential.

In reality horses and bears do not have characteristically identifiable colours. For these subjects, therefore, pure simplicity, though idealized and carefully attended to, is preferable— more carefully than with the coloured examples, since we cannot resort to the brush to express the details.

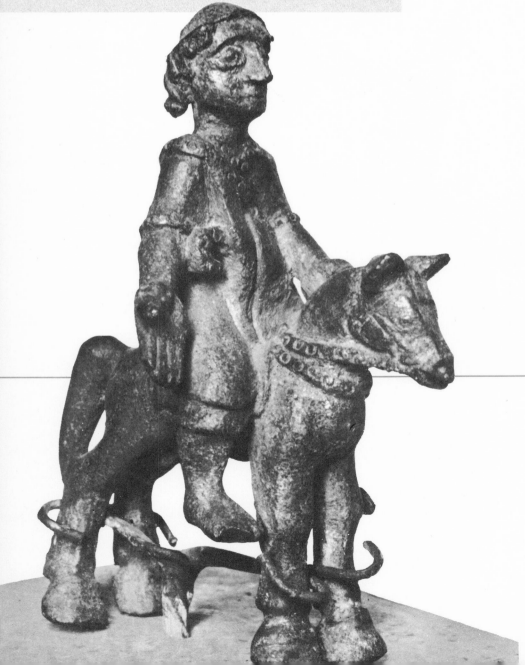

Bronze equestrian figure of the Iberian period found in Southern Spain. Note the exaggeration of the proportions which combine to lend the subject a pleasing ingenuousness.

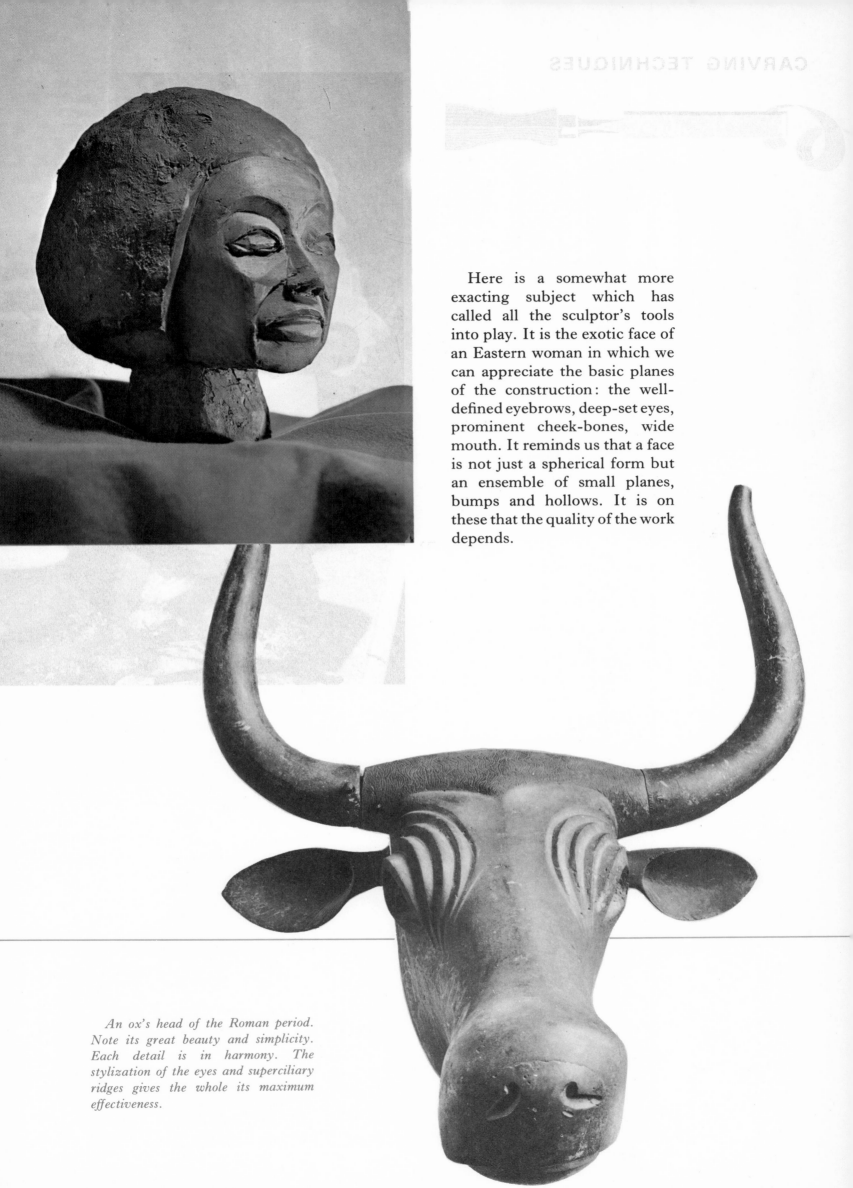

Here is a somewhat more exacting subject which has called all the sculptor's tools into play. It is the exotic face of an Eastern woman in which we can appreciate the basic planes of the construction: the well-defined eyebrows, deep-set eyes, prominent cheek-bones, wide mouth. It reminds us that a face is not just a spherical form but an ensemble of small planes, bumps and hollows. It is on these that the quality of the work depends.

An ox's head of the Roman period. Note its great beauty and simplicity. Each detail is in harmony. The stylization of the eyes and superciliary ridges gives the whole its maximum effectiveness.

We can represent a subject, working from a starting-point other than the one we have examined so far. That is to say we can cut away from a block of material all the superfluous part and leave the essential, the figure we want.

Remember that in a mass of iron, a stone, a piece of wood exist all the subjects you can possibly imagine. It is up to our hands to discover them. It is as if the figures were enveloped in a dense layer of matter and we, with the aid of certain tools must clear away this useless layer and finally liberate the figure. Professional sculptors work with chisels, drills and mallets to extract their visions from marble, and sometimes, because of the hard yet brittle nature of the material employed, this may require long years of labour.

You have a free choice as far as materials are concerned, but some are certainly more suitable and easier to cut. Two materials are particularly appropriate for your purpose: plaster of Paris and wood.

Plaster of Paris

We have to start by making a block of this material. All we have to do is sprinkle some handfuls of the powdered plaster into a little water until it shows above the surface. Allow the plaster to slake for two minutes, pour off excess water, then stir very gently so as not to cause air bubbles.

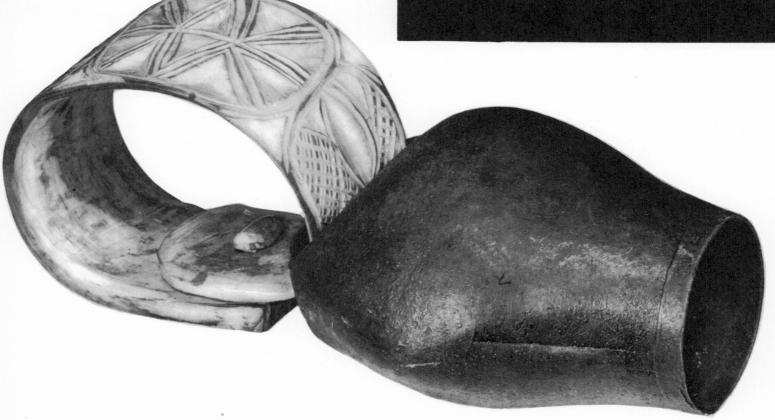

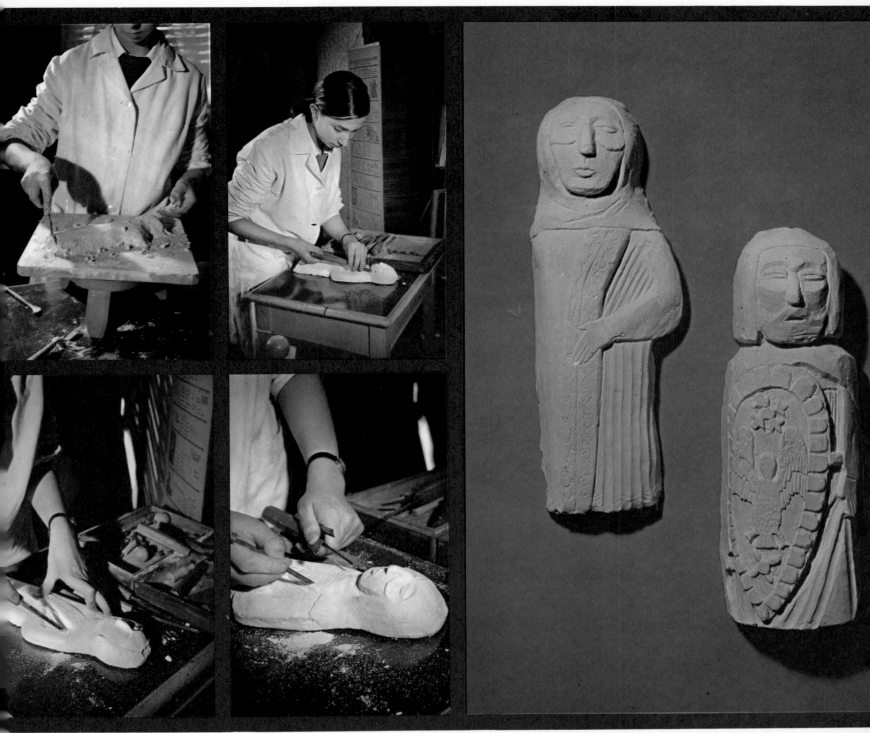

Pour the paste thus formed on to a board or into a mould and wait for it to dry. In a few hours the rough plaster will be ready.

Plaster of Paris has various advantages: it is relatively soft and easy to cut; it has the appearance of white marble and lends itself to colouring either while it is hardening or after it has dried. Two or three types of simple wood chisels suffice for the work.

In our first experiments at any rate we must resist the temptation to carve whole figures or detail in relief since plaster is a brittle material.

The two examples reproduced on these pages give some idea of what can be most conveniently produced by this method.

The following are the different stages necessary for producing a plaster sculpture:

1. After mixing the plaster, heap it up on a wooden board.

2. If you smooth it as it hardens, you can give it approximately the shape you intend to represent.

3. Next you must get rid of all the superfluous parts.

4. In fully three-dimensional sculpture first cut away the large areas.

5. Then pass on to the details. (Take note of the various edges of the chisels; each produces its characteristic incision.)

6. Now for the final result. One of the carvings is one we have carried out. The other was made on the same principles.

Wood

Compared with plaster it is not very different to work on. Furthermore, being pliant and less brittle, it can be used in a greater variety of ways.

Attractive objects can be made on simple, decorative lines such as the cow-bell collar (carved by a Sardinian shepherd) which you see reproduced on the facing page.

Not all woods, though, are suitable for carving. Avoid soft and fibrous woods such as poplar and pine. Fruit-tree woods and willow, however, are easy to cut and particularly pliable.

SCULPTURE IN THE PAST

Sculpture was born with Man, and it is logical to assume that it was the first of the arts since it invites the most realistic representation. Painting and drawing pose problems of volume and space (resolved by perspective) which sculpture dealt with from the start.

The concepts of sculpture, like those of all the arts, have greatly changed in the course of the centuries. The Egyptians for example were anxious that their work should endure—and how successful they were—and therefore used low-relief (extremely resistant to erosion) or else carved the subject in a block of stone. Furthermore they attached the arms and legs to the torso in order to avoid fracturing at narrow parts. Some people say that the characteristic head-dresses were a 'professional' device to avoid weakness at the neck.

In this respect the Greeks were more careless: witness the present number of Greek sculptures that lack arms and head! The Greeks' sole concern was to represent the beauty of the human figure.

After the less expressive Romanesque sculpture—though it had a beauty of its own—the Renaissance during the late Middle Ages went back to the Greek love of the human body which they interpreted more forcefully and with increased technical freedom.

In the late nineteenth century Rodin gave sculpture a new vitality, inspiring many twentieth-century sculptors,

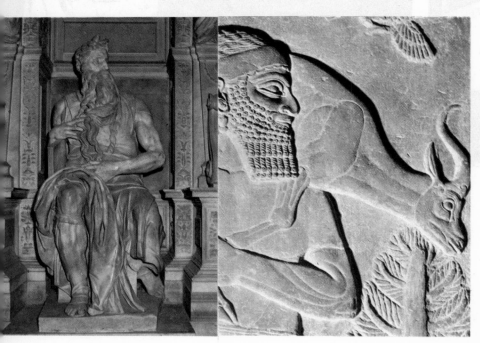

Michelangelo: *Moses* Assyrian art: *Return from the hunt*

some of whom found new forms of expression, symbolic, expressionistic and always stylized.

In our own day, artistic freedom has invaded sculptural expression no less than the materials employed. The González piece on the right, for instance, shows great skill with welded iron. Abstractions, mobiles, mechanical fantasies . . . all experiments which history will judge from a detached angle, giving a measured assessment to the evolution of the arts.

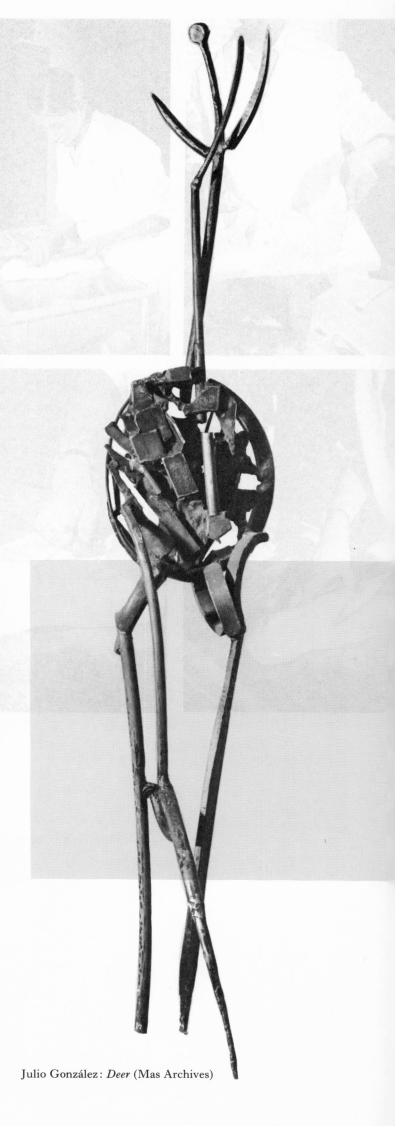

Julio González: *Deer* (Mas Archives)

The rules of art

Everything in the world has its own rules; art is no exception. But a distinction should be made between rules and dogmas. Rules in our case do not imply an obligation to do things in a particular way. They are guide-lines to help you to do what you want.

Let us take an example: all pencils are more or less the same, but this does not mean that the drawings for which they are used should be the same. Just as you cannot draw without a pencil, so in the absence of rules, it would be difficult to express what you feel.

We agree then: all the ideas you will be introduced to are not dogmas but things you must know even if you deliberately ignore them. You will see how, after learning these rules, you will feel more able and therefore freer to express your ideas in pictures.

LIGHT AND SHADE
Objects in general are not entirely black or white. The art of giving each detail its correct tone, its precise degree of greyness, is called 'chiaroscuro' (light and shade).

PERSPECTIVE
Objects vary in form and scale according to whether they are near or far. The art of representing these variations of distance or viewpoint on a flat plane is known as 'perspective'.

COMPOSITION
Objects are attractive or unattractive, long or round, big or small ... The art of arranging them together in a harmonious way is called 'composition'. Knowing how to compose is the first step towards being an artist.

THE HUMAN FORM
Objects have a fixed appearance. Man, on the contrary, is variable. He moves, expresses himself, feels ... You need to study him carefully to be able to draw him moving, feeling, expressing himself ...

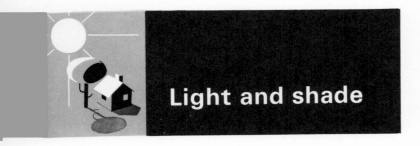

Light and shade

Man has always tried to represent light. It proved beyond him in prehistoric times. In the Gothic period light lay passively between panels of gold and blue backgrounds. The Renaissance, with Masaccio and Giotto, began to represent volume. The phenomenon we call 'aerial perspective' originated in the paintings of Leonardo da Vinci in whose background landscapes there are changes of tone and colour as trees, mountains etc. recede into the distance. Two centuries later Rembrandt discovered chiaroscuro.

Chiaroscuro opens up two possibilities: characterization of the form of objects, and employment of a new mode of expression. In fact, the light absorbed by the object tells us whether it is a plane surface, curved, spherical etc. Furthermore, according to the amount of illumination (hard, soft, contrasted . . .) the model can express sadness, joy, drama.

The most important thing about light and shade is the fidelity of the various tones to reality and the relation between them. The only way to treat it successfully is by continual comparison. Compare one grey with another, learn how to distinguish a 'total black' or a 'pure white' from 'near black' and 'near white'; study the backgrounds with their reflections and shadows. In short, look at

(a) When the shadow on a curved surface is progressive, you need to understand what grey zones compose it.

(b) Here is the completed drawing. Compare it with the one above, and you will observe the effect of stumping which has united all the tones into a single progression.

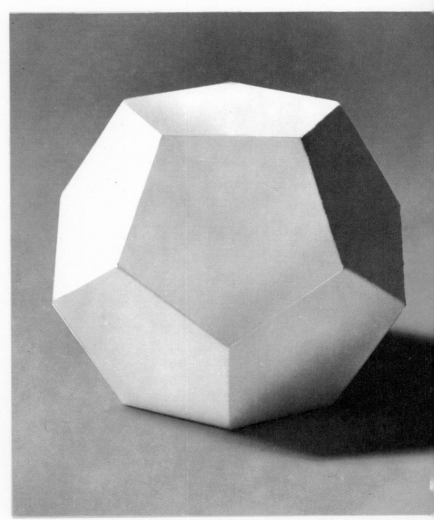

the whole subject in a single-minded way; this implies continual practice.

What is one to practise with? Any object, since everything shows light and shade. All the same, it is advisable to start with simple objects with plane surfaces. A geometric form is ideal.

This dodecahedron provides an interesting exercise in light and shade. On the facing page you will see the geometrical plan for constructing one. Do this carefully and you will have a first-class model for your experiments. This can be carried out as a group exercise. Compare results and note where drawings have gone wrong. It is a good idea to do these by daylight. This ensures a consistent lighting for all those taking part, and a fair comparison of results.

49

Here is another pattern. This time it is for an icosahedron, likewise very fascinating because of the number (twenty) of faces it offers.

Trace this pattern on to a sheet of drawing-paper or thin card. The dotted lines indicate the folding points for the shapes and the hinges.

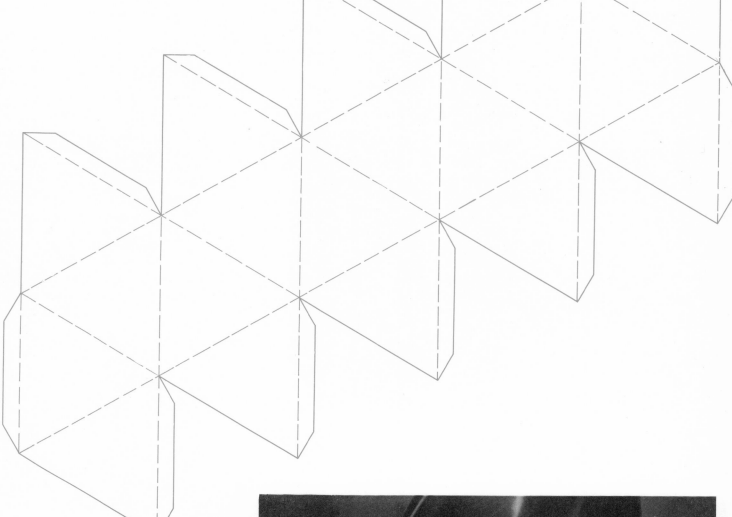

Of course there are endless possibilities for such models. Once you have practised with simple forms, you can experiment with other more complex ones. These models made from folded paper or thin card are particularly suited for drawing because of the irregularity of their shadows.

The choice of these subjects and the lighting depends on you and your skill in making them.

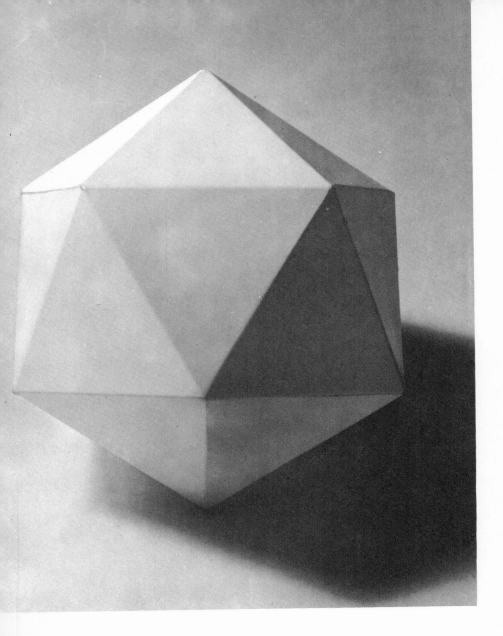

Take the polyhedron of pages 48 to 49, and having satisfied yourself that it is carefully made, pass on to the question of lighting, seeing that the range of greys shows the maximum variety.

You need a sheet of white paper, a soft pencil, a stump (alternatively your fingers will serve the same purpose) and a bottle of fixative to 'fix' the completed work.

A word of warning. Before you begin, here is some advice :

The divisions between one tone and the next should depend on a contrast of greys not on lines dividing them off. There are no lines in nature— look around !—only light and shade.

Do not expect to arrive at the correct tones at the first attempt. It is better to be careful and begin by trying out the light tones and endeavouring to determine the contrasts with soft greys. When you are sure you have got the correct relationships between these tones you can emphasize them.

Remember that you cannot rub out when the tones are too dense without risking a messy result.

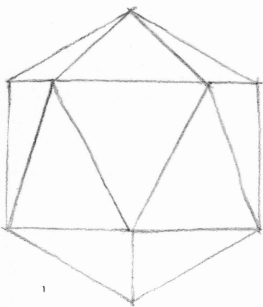

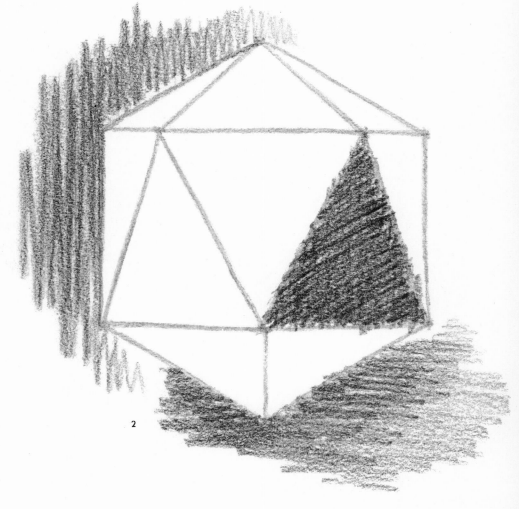

1. *First, the drawing. Without an accurate outline, you will be wasting your time shading the greys because the result will be faulty.*

2. *Continuing, take the extreme tones. Begin from the black, neglecting the white. You will also do well to bear in mind the background and the projected shadows. In this way you can determine the limits of the subject.*

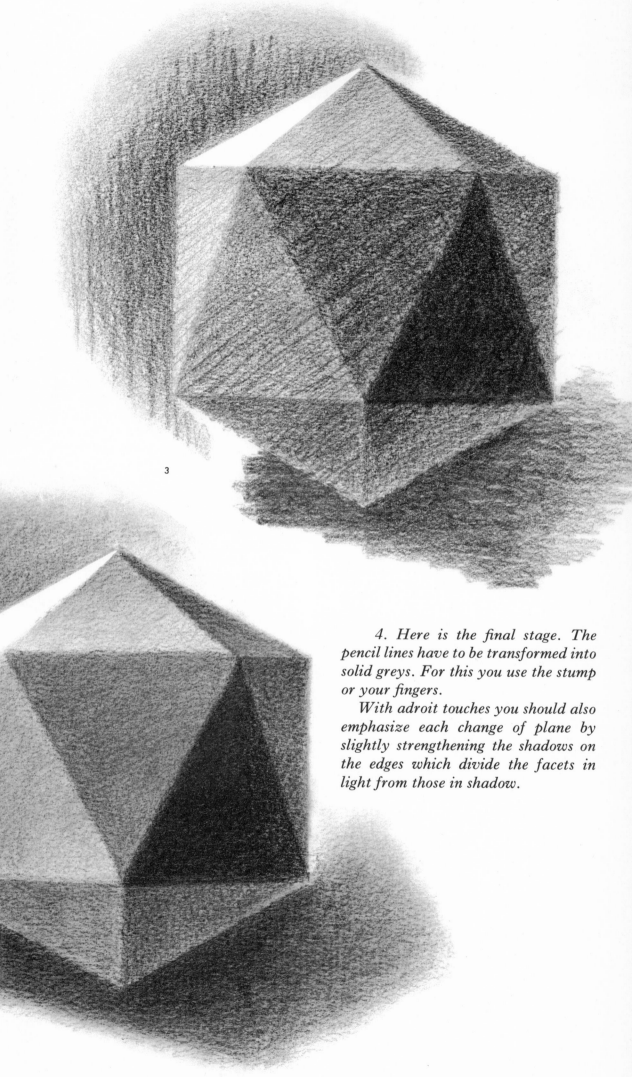

3. *Now apply all the grey tones between the black triangle and the white (top left-hand part), increasing them in intensity until they match up to those in the model. The background should also be touched up and strengthened, especially where it meets the lighter facets of the model.*

Remember that by this stage the dividing lines should have disappeared.

3

4. *Here is the final stage. The pencil lines have to be transformed into solid greys. For this you use the stump or your fingers.*

With adroit touches you should also emphasize each change of plane by slightly strengthening the shadows on the edges which divide the facets in light from those in shadow.

4

Perspective

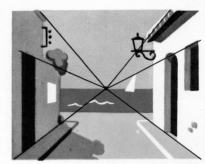

Midway view-point, *corresponding to the view we would have from a balcony of midway height (a favourite viewpoint with artists).*

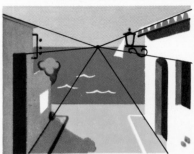

High viewpoint, *as from a roof terrace. The mechanics of perspective, however, remain the same.*

Low viewpoint, *street level. As you see, it is always the horizon that determines our position.*

We now come to what might seem to be a boring subject, perspective. All the same, without some knowledge of perspective it is impossible to draw, since it is the basis of every picture. Remember that even the positions of the human body must be observed in terms of perspective. This also applies to facial expression: eyes, nose, mouth assume different forms according to the viewing point.

You will need a set-square, but once you have learned the laws of perspective, you need not bother about the mathematical exactness of lines which you will make mentally. But as a result of knowing about perspective your drawings will have a logical basis.

The system depends on an imaginary line called the **horizon** and on **vanishing points** (VP's) situated on it. Let us look at some examples:

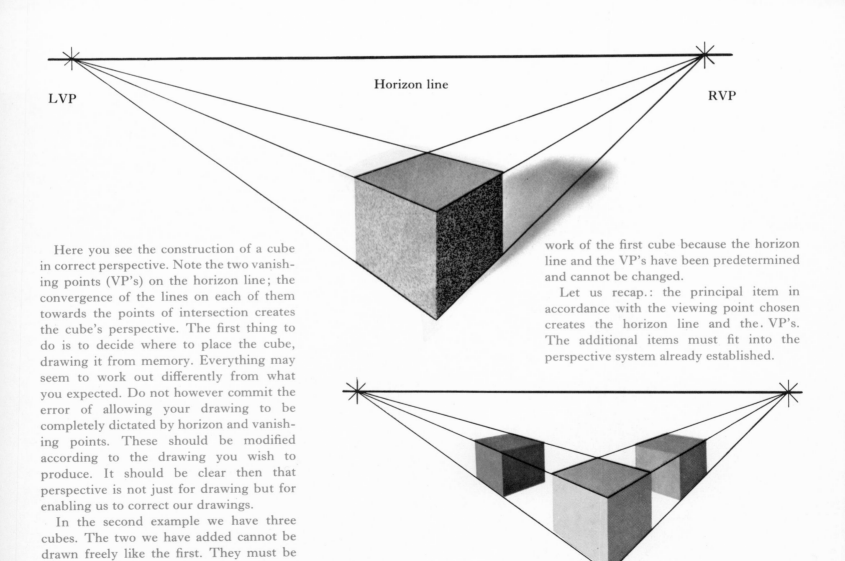

Horizon line

LVP

RVP

Here you see the construction of a cube in correct perspective. Note the two vanishing points (VP's) on the horizon line; the convergence of the lines on each of them towards the points of intersection creates the cube's perspective. The first thing to do is to decide where to place the cube, drawing it from memory. Everything may seem to work out differently from what you expected. Do not however commit the error of allowing your drawing to be completely dictated by horizon and vanishing points. These should be modified according to the drawing you wish to produce. It should be clear then that perspective is not just for drawing but for enabling us to correct our drawings.

In the second example we have three cubes. The two we have added cannot be drawn freely like the first. They must be integrated within the perspective frame-

work of the first cube because the horizon line and the VP's have been predetermined and cannot be changed.

Let us recap.: the principal item in accordance with the viewing point chosen creates the horizon line and the. VP's. The additional items must fit into the perspective system already established.

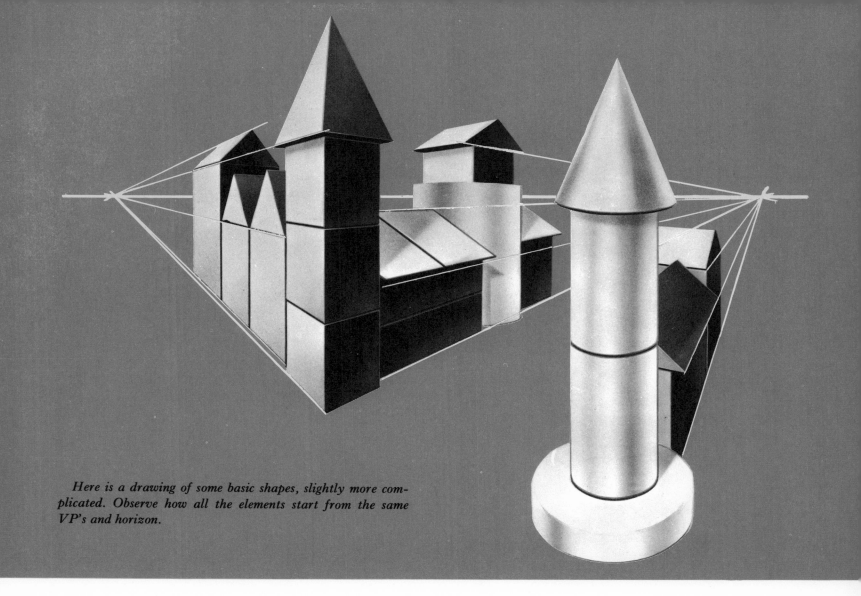

Here is a drawing of some basic shapes, slightly more complicated. Observe how all the elements start from the same VP's and horizon.

Luca Carlevaris:
Venetian Reception (detail)
Bellini Archives, Rome

Since perspective applies to any plane figure, we must also consider **the circle** (a plane figure, bounded by a closed curved line) which changes according to its position in relation to the horizon. If the circle is inscribed in a square, and the latter is distorted by perspective, the circle will assume the form of an ellipse.

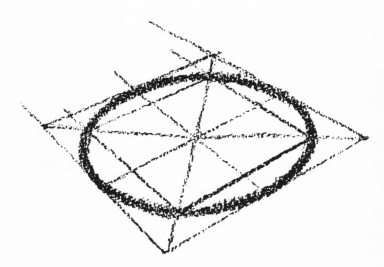

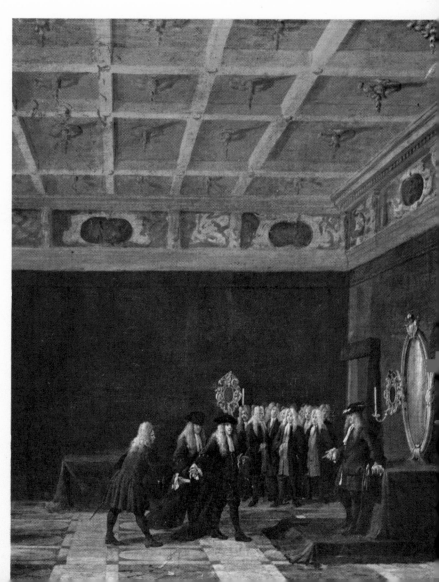

The Renaissance saw the birth of perspective. It was without doubt a great conquest of forms; the perfect representation of reality became possible.

As happens with all innovations, this led to a certain exaggeration. The subjects became somewhat cold and betrayed the artists' desire to set themselves difficult problems of construction. For this purpose they chose interiors and architectural settings which gave scope for such technical virtuosity.

Composition

It is by no means easy to explain composition. And this is logical enough because the sense of composition is a thing the artist has within himself. He composes intuitively, aided only by good taste and an aesthetic sense. However certain things can be learned. There are a number of principles which we shall examine in turn.

Essentially, composition is the art of combining the various elements of a subject in an aesthetically satisfying way, so that the whole effect is agreeable to the eye. Apart from **symmetrical** composition, which needs no explanation, there are two fairly practical formulas for composition:

The first is the **rule of compensation,** based on the following premise:

'The bigger the mass, the more towards the centre. The smaller the mass, the more towards the edge.'

The second has its source in the **'Golden Rule'** of the principles of composition. Briefly, it suggests the division of the picture-plane into three horizontal and three vertical parts. Thus one can avoid symmetry and obtain a harmonious localization of the components.

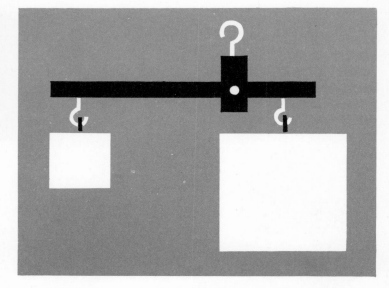

Rule of compensation

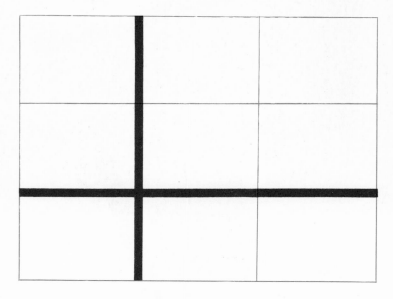

Rule of asymmetry

Here are two examples of what has been stated. In the first (Pietà by Buonconsiglio) we see the rule of compensation applied ; in the second (Manet's On the Beach) the painter has adopted the asymmetric rule (of which the L shape is a characteristic).

As you progress, you will observe many such paintings. They will reveal to you the secret of their composition.

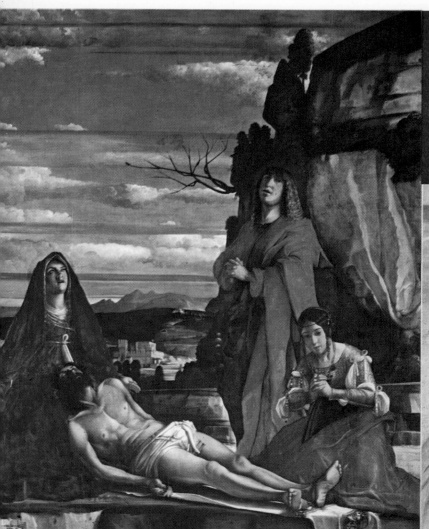

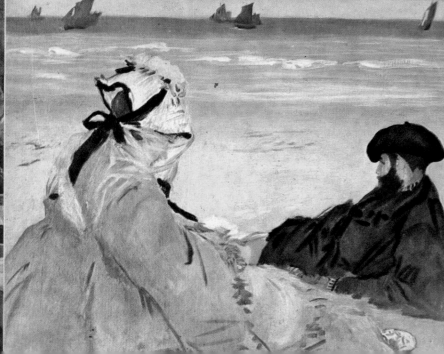

But with composition there are so many ways open, that you should not be content with these two rules. You should create your own compositions. All that matters is that the result should please the eye.

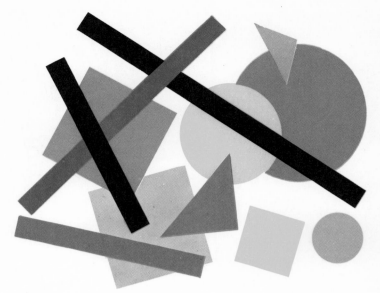

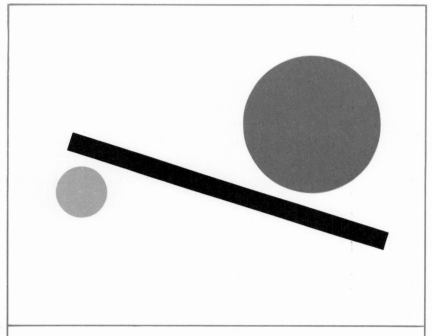

There is one very fascinating method which allows every kind of experiment. It consists of cutting coloured paper into pieces of various shapes and sizes and arranging them on a sheet of white paper. They don't have to mean anything; the thing is to produce a balanced composition. Apply the two rules you have learned if they suit you but feel completely free.

Here are some possibilities for you to consider:

1. Simple play of round shapes of various sizes with a straight line that unites them.

2. A combination of squares and lines with a round form as a counter-weight.

3. Landscape scheme. Typical asymmetrical L shape. Note that none of the tree-trunks have the identical slope. They are counterbalanced by the little house on the left.

4. Here we have a very important device. Note how the various shapes continue the same lines of composition, thereby giving a strong feeling of order and simplicity. The pink circle merely provides an element of variety.

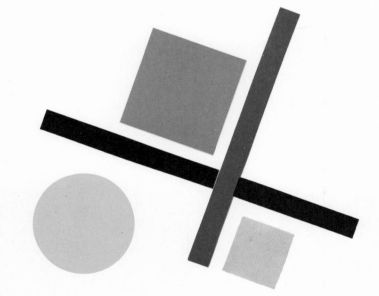

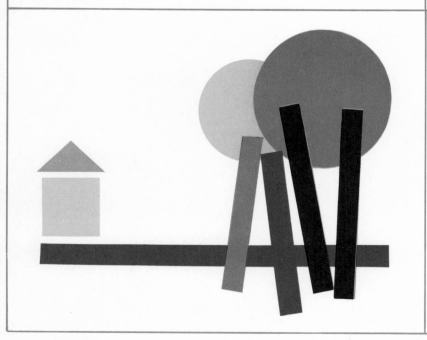

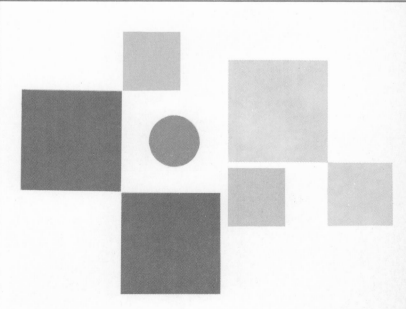

5

6

5. *Here is another important device. We call it composition by* **point of contrast.** *This would be a dull symmetrical composition without the pink disk at the top which not only breaks the monotony but also conveys a feeling of movement to the picture.*

6. *Here the point of contrast does not affect the symmetry but introduces an element of variety into an ensemble of straight lines, at the same time filling a space which would otherwise have no sense.*

Now experiment for yourself. These six examples are not the whole story. You can compose scores of others, using similar elements.

Do not by-pass this technique. It is one of the most important for developing the 'instinct' for composition. In fact composition is largely a matter of instinct and almost defies definition.

You should make your own experiments and your own discoveries around the few fixed rules. Cut out lots of different shapes and you will see how each new combination of elements will suggest endless subjects. Do not finally stick down the pieces until you are satisfied that you have produced an attractive and well-balanced composition. Exploit this particular advantage, which is not always shared by other techniques, namely the opportunity for making corrections.

De Staël with this work The Paint-brush *provides us with an example of pure composition.*

This work by Max Ernst Variations on the theme of the Aeolian Harp *shows us the possibilities of composition with disconnected elements.*

The human figure

You will have been wondering when we were going to consider this subject. Compared with the human figure other things seem unimportant. This is of course not so, but the human figure well delineated is certainly one of the most inspiring and expressive subjects.

First and foremost we should look at **proportions.** From this point of view the drawing on the right will be useful. Note particularly the relationship between the head and the rest of the body. In actual fact a man's height equals seven heads, but in drawing it is advisable to assume eight heads as the proportion if you are aiming at a more graceful and pleasing result.

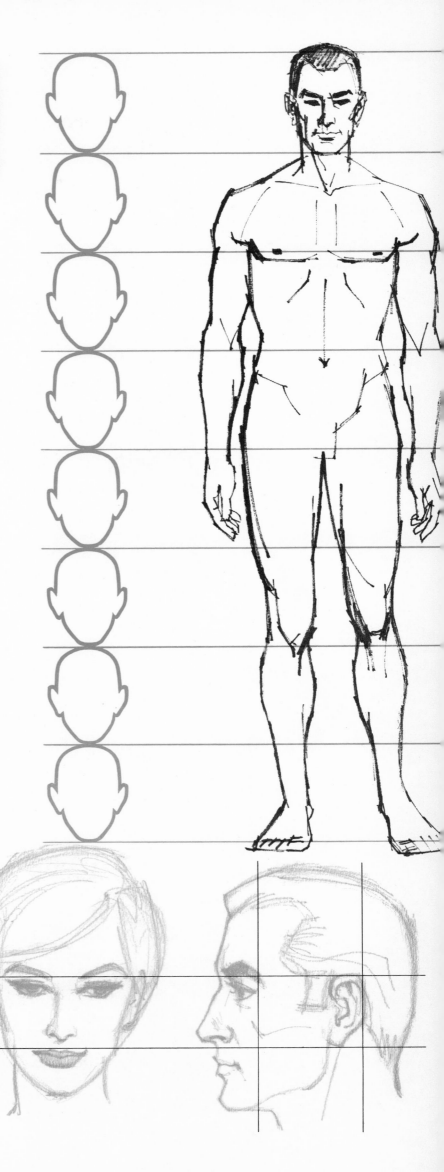

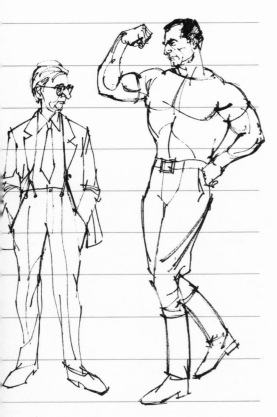

Here we have a comparison between an average man (seven heads) and a heavyweight (nine heads). All these variants are admissible according to the character we want to give the figure. We use them to express the personality of each subject.

Other important proportions are those of the head: the eyebrows should be on a level with the top of the ears, the height of the nose should equal the distance between the mouth and the chin etc. You can draw interesting conclusions by looking at the lines superimposed on the drawings. Keeping these in mind try drawing a head yourself, i.e. in accordance with the proportions indicated.

59

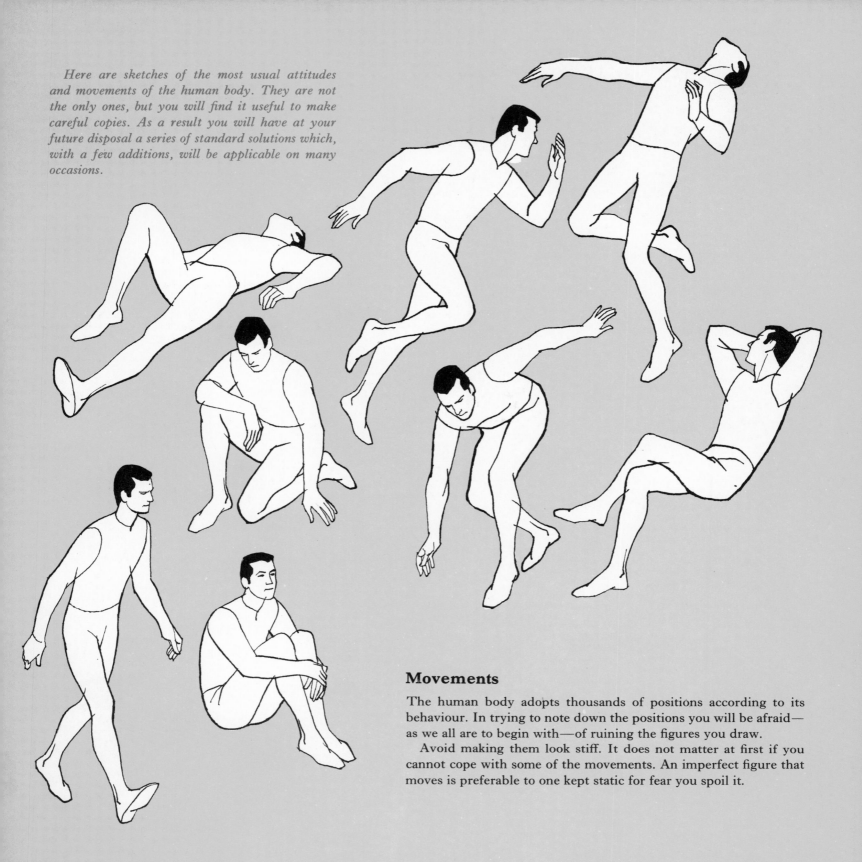

Here are sketches of the most usual attitudes and movements of the human body. They are not the only ones, but you will find it useful to make careful copies. As a result you will have at your future disposal a series of standard solutions which, with a few additions, will be applicable on many occasions.

Movements

The human body adopts thousands of positions according to its behaviour. In trying to note down the positions you will be afraid— as we all are to begin with—of ruining the figures you draw.

Avoid making them look stiff. It does not matter at first if you cannot cope with some of the movements. An imperfect figure that moves is preferable to one kept static for fear you spoil it.

Facial expressions

We do not propose at this stage to study the muscles that determine facial expressions. As with the human form, we will be content to give a few indications which you will find useful for your future drawings.

On the right-hand page you will observe the principal facial expressions. Don't let it surprise you to see them portrayed on eggs; the egg is the nearest natural form to the shape of a head! Furthermore it invites you to amuse yourself in a similar way depicting facial expressions (even caricaturing your friends). You can increase the effect by adding hair and whiskers in the form of raw or cotton wool.

Now study the expressions. They are simplified but unmistakable. Analyse them and try to imitate them. You will certainly realize why you were unsuccessful with some expressions before.

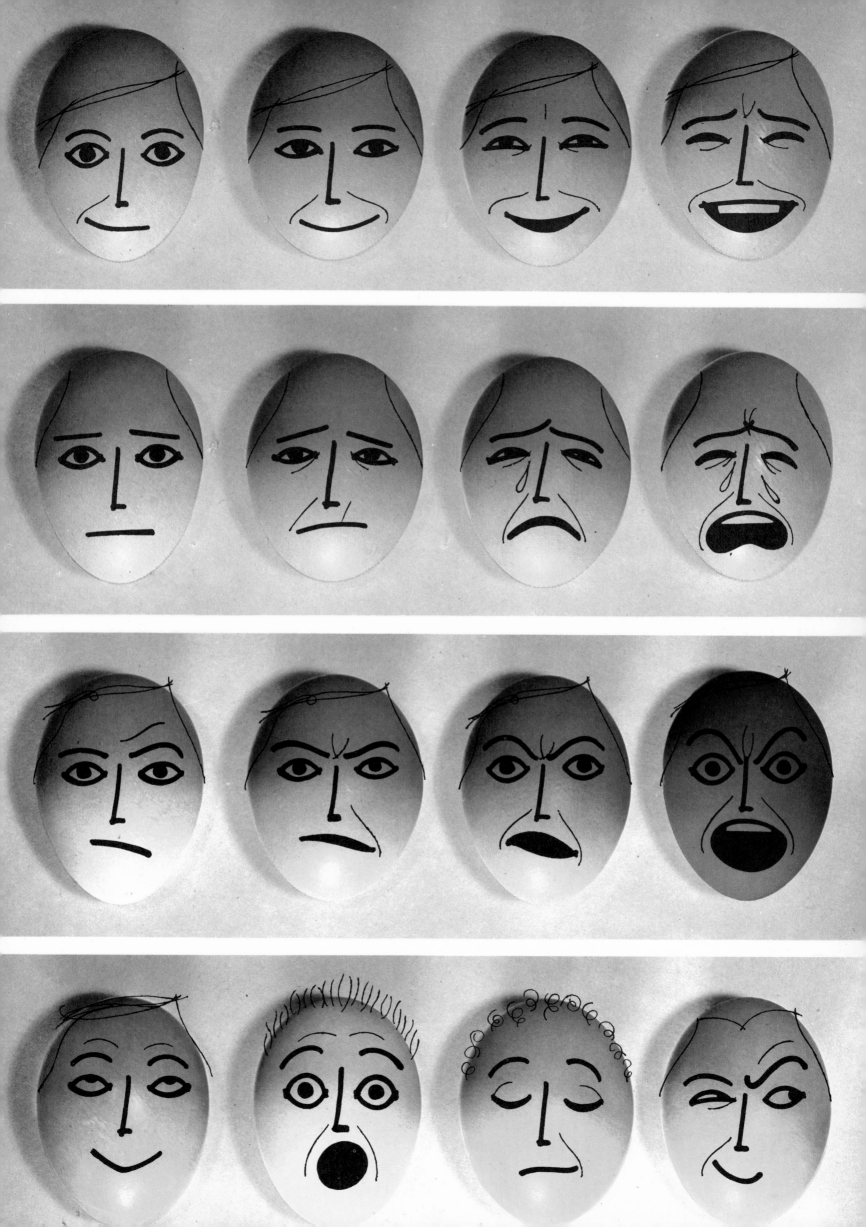

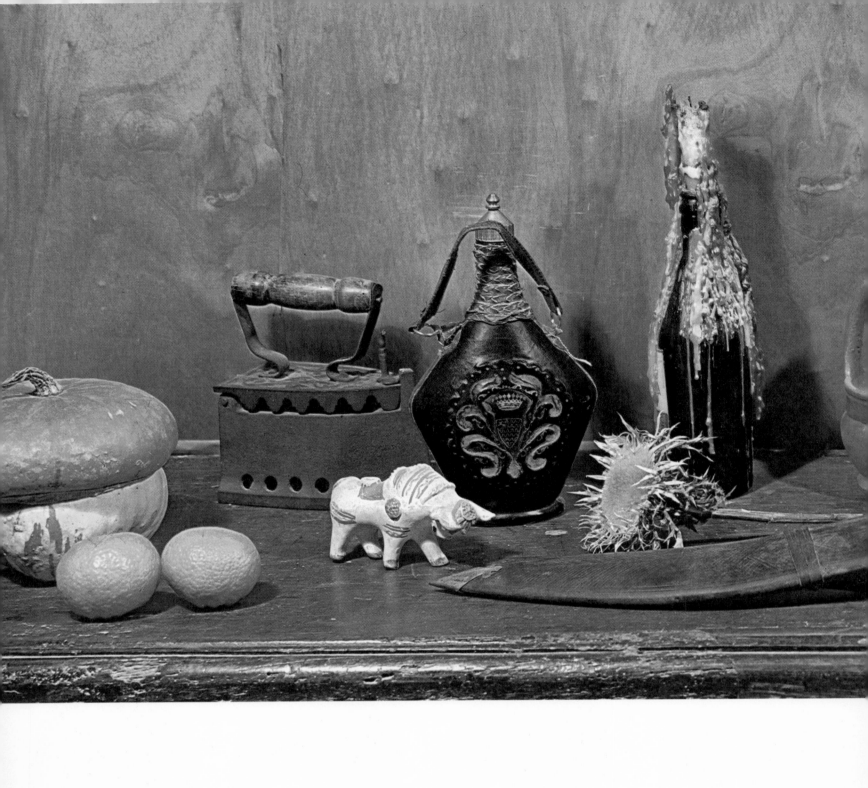

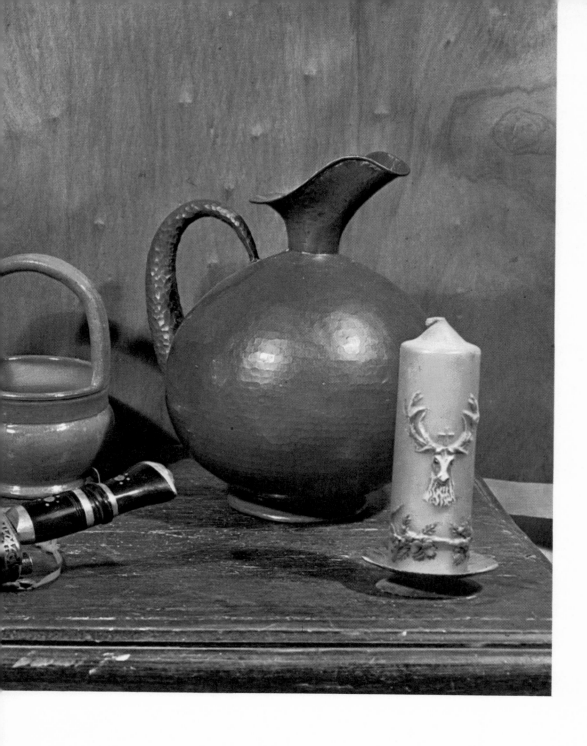

Representation of reality

Imagination is a splendid thing, but now we must come to grips with reality.

The world is full of objects, each with its own shape, and every shape provides us with a potential experiment. The present exercise requires you to copy the forms you see, but, although this is the task, it is not the target. Studying forms means understanding, analysing them—and also, why not?—improving them.

We are about to embark on still-life drawing. By doing it we shall learn that every object has a characteristic feature which we must seize on. An assemblage of various objects allows us to learn about their proportions and composition. From the discipline of this exercise, we shall gain a certain dexterity and mental experience which will be of considerable help towards the appreciation of any detail in any subject.

Draw all the objects in front of you—the ash-tray, lighter, the magazine left on the armchair, the bottle of wine, the glass . . . Nothing is useless as long as it is taken from reality. You will become aware that lots of forms escaped you (they were never more than mental images although they were close at hand for years). Rest assured that even in the least promising reality you will find a source of inspiration.

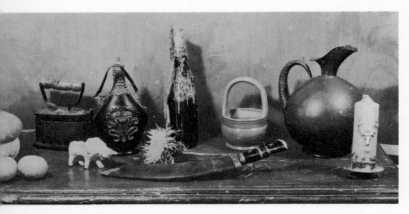

Analysis of the subject

The whole secret lies in contrast. Compare distances, heights, widths . . . You must make your mind a precision instrument. You must learn how to measure with a single glance the different relationships between the dimensions of the various objects. Let us follow this process step by step:

1. Take, for example, the objects in the photograph. The most varied shapes and volumes possible have been chosen. Cultivate the habit of making a thorough survey of the elements you wish to depict before picking up your pencil. Let us make a careful analysis of the objects involved in the present exercise:

The flat-iron and the ceramic basket are the same height.
The bottle is situated in the centre of the photograph.
The copper vessel is lower than the bottle but higher than the ceramic basket etc.

At this planning stage, it will be a help to divide the picture area into four sections by means of a

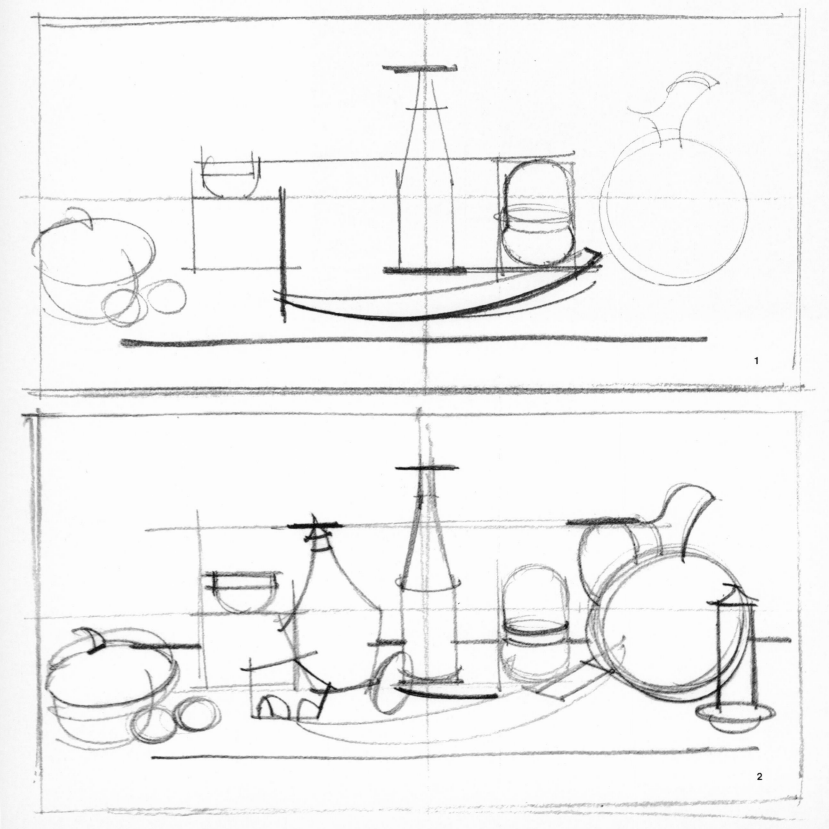

horizontal and a vertical line. This will facilitate the correct placing of each element.

2. The basic points have been settled. Now you should arrange the intermediate objects, and begin to compose the whole.

Things are beginning to take shape, but, before proceeding further, you should make a general check of proportions to confirm that everything is going to be right. Correction at this stage is nothing to what it would be later. If it is satisfactory we can now construct each individual element. You already know something about perspective, volume, final outline . . .

And, apropos perspective, do not forget that all the constituent parts of a subject should be within the same perspective system. Generally, in this kind of subject, perspective is not all that exacting, but be careful with the cylindrical elements. Their bases must conform to the general viewing point.

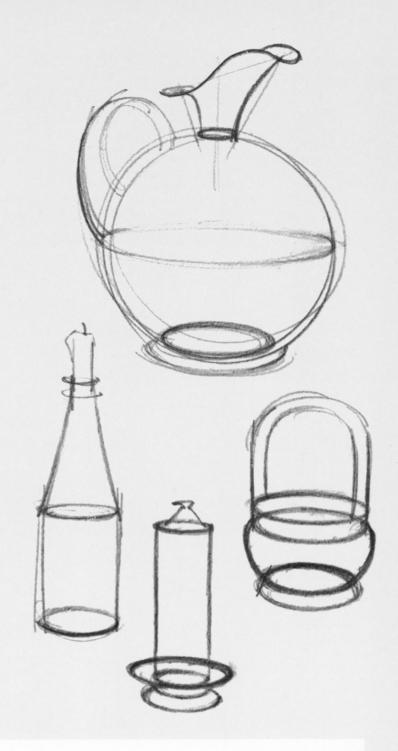

Remember that in the perspective of cylinders the curvature of the base differs from that of the upper section (see diagram). Be very careful about this detail because it is the most common source of error among the uninitiated.

3. And now let us set about the actual drawing. The structure is already settled. It only remains to complete each shape accurately. Meantime analyse the 'reason' for these forms and try to improve on reality by bringing out the most attractive or salient characteristics.

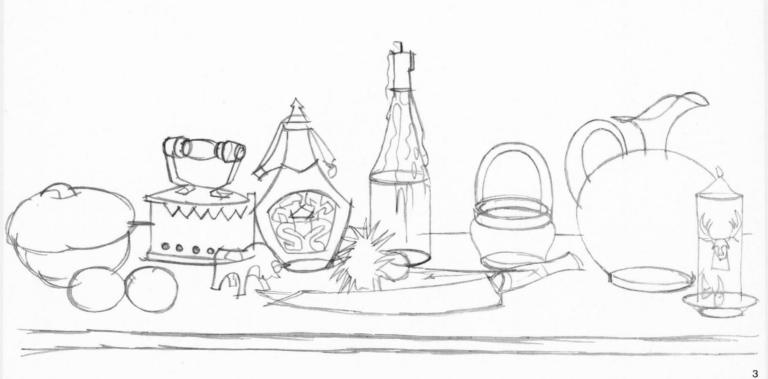

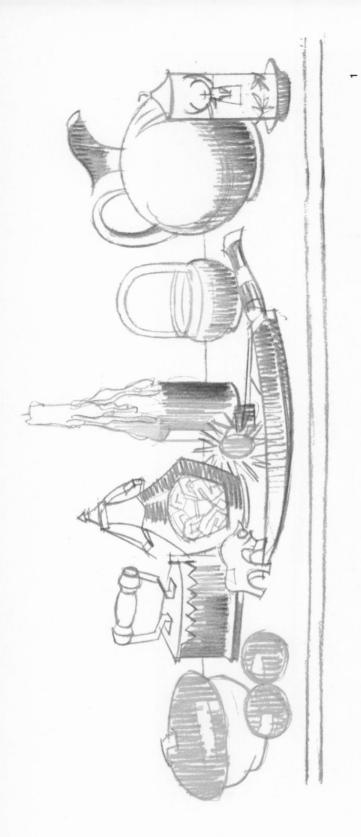

1

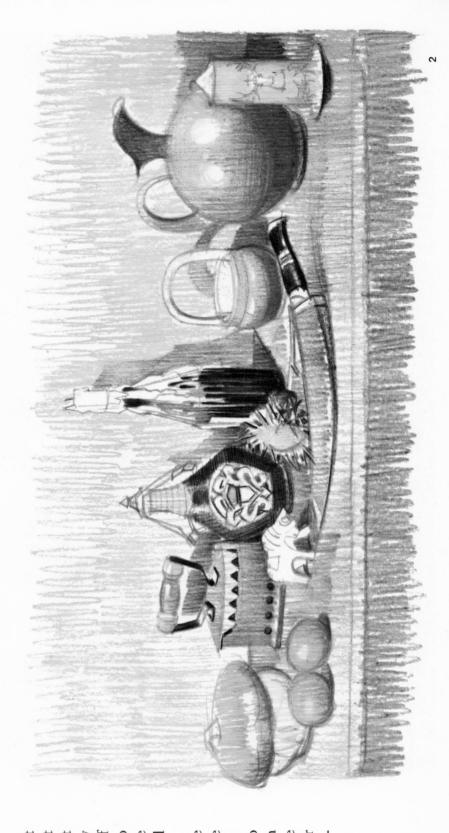

2

The construction of colour

Since we are dealing with the representation of reality, we must go further than the mere study of forms and proportions. Reality is composed of the following constituents:

form—volume—light—colour—material.

Form has been studied in the preceding pages. Taking things in order, we should now deal with volume. It is determined in two ways:

> by perspective
> by light and shade (chiaroscuro).

We already know how to cope with perspective; it is not very complicated in the present example, and we have examined it together in our study of shapes. There is still, however, the more important factor of volume, i.e. light and shade.

1. Here is a preliminary study of light and shade. Naturally we employ light colours which serve as a guide without interfering with the final picture. Note how different colours are used for the study of light and shade for each object. This is so that the provisional lines do not cause confusion when we come to the final colouring.

2. And now, though without undue haste, is the moment to decide on the colours.

At this stage of the work you must also take into account the material of which each object is made. Its surface may be shiny, rough, transparent etc. The colour will help towards the complete identification of each item.

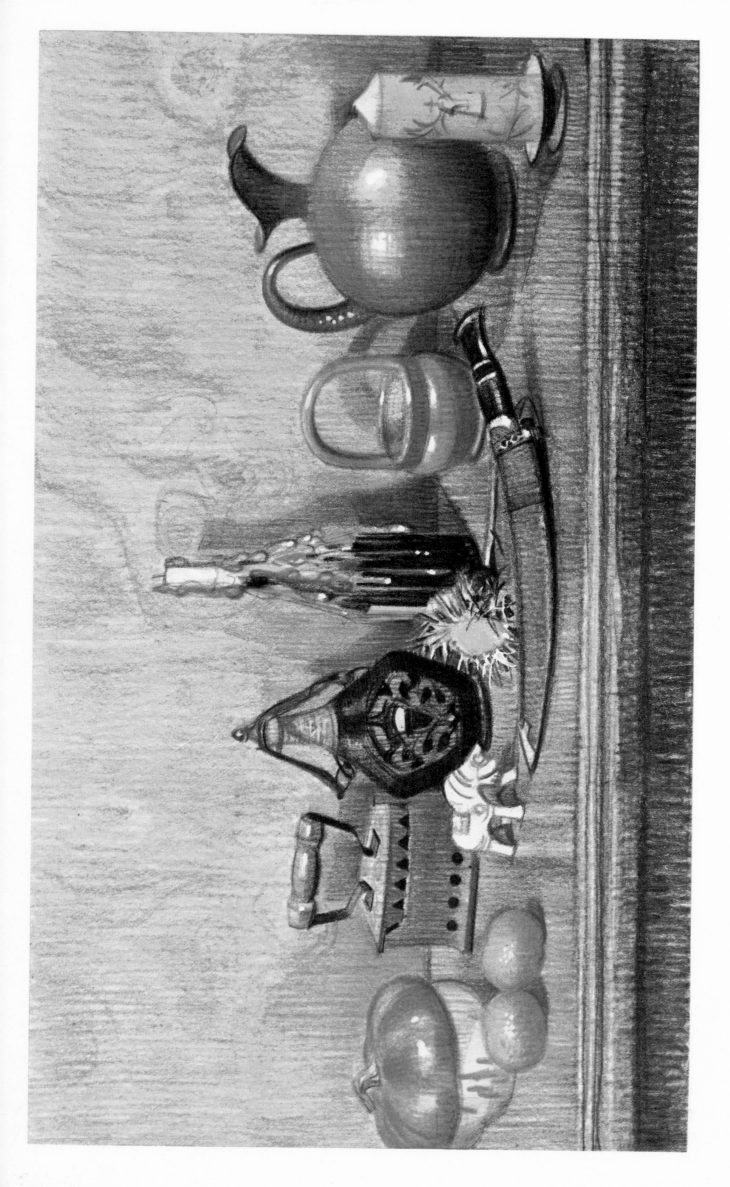

At length you see the finished drawing. Obviously it is a faithful reproduction of the model, but it is a good thing to submit to this kind of discipline now and again. Apart from encouraging dexterity and imparting confidence, it helps you to understand inanimate objects and gives you a basis for the successful carrying out of free interpretation.

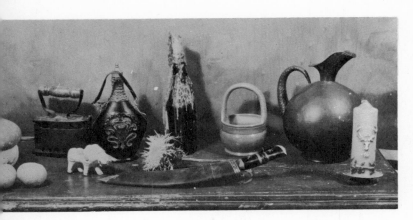

Idealization of the subject

Now we are embarking on the fascinating business of the free interpretation of reality.

No one would deny the beauty of reality, but this beauty is not always simple. Objects and nature are as they are, but their forms can—and should—suggest new forms to the artist—simpler, more evocative, more descriptive and even more attractive, without forfeiting their significance and original essence.

It is very difficult to lay down rules for this process of simplification. The only valid one is that you should exaggerate characteristic details of the model.

Let us take the objects from the previous exercise for our example. Observe them one by one and analyse them carefully. You cannot arrive at the essence of an object without a full knowledge of it. Precisely for this reason we have left this lesson to the last. We have already familiarized ourselves with these objects in the lesson before and, by representing them as they are, we mastered their form and proportions.

Let us inspect one of the most characteristic objects: the copper vessel. What is its essence? First and foremost a complete sphere. At the top is a cup-shaped mouthpiece attached to the sphere by a slender funnel neck. A semi-circular handle completes this object.

So what do we have to do? The sphere needs no modification; it is attractive as it is. The part that lends itself most to idealization is the funnel neck which is very characteristic. We must exaggerate its lines, emphasize the length and slenderness of the neck, clarify its function. As far as the handle is concerned, a slight simplification can be obtained by merely exaggerating the semi-circle—nothing else is needed.

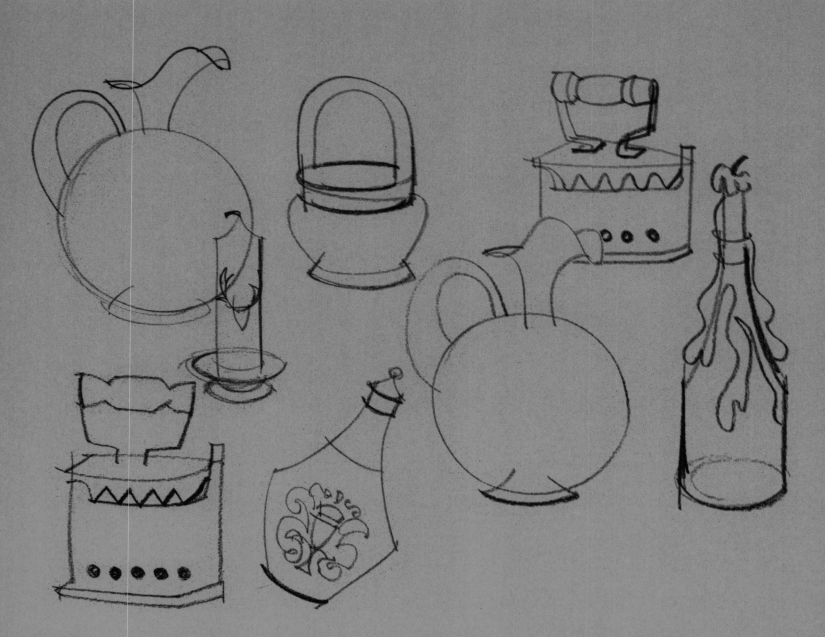

In these pages you will see various studies in this process of idealization. For the bottle we have exploited the long neck with the candle at the top, making a feature of the melted wax. For the flat-iron we have made a feature of its box-like shape and its functional aspect. The long candle with its simplicity of line is attractive enough as it is. We have emphasized the pointed corners, the pentagonal form and the slender neck of the flask. The porcelain basket is the most difficult object, but even in this case something can be done if we dwell on its curves and its particularly elongated handle. The scimitar proved easier; it was enough to exaggerate the curve and idealize the hilt. The other elements are of secondary importance, and a slight revision of their original forms sufficed.

You yourself should try similar experiments with other objects. Study them carefully, drawing them according to their real proportions. Then put them on one side and draw them several times from memory, with increasing boldness and freedom on each occasion. If you pursue this path the idealization should just happen naturally.

Look at the idealized subject below, completely finished. Note that the colours too have been modified, the shadows simplified. The colours, though close to those of the model, are freely interpreted.

In this kind of subject, even perspective is sacrificed to produce a more expressive result.

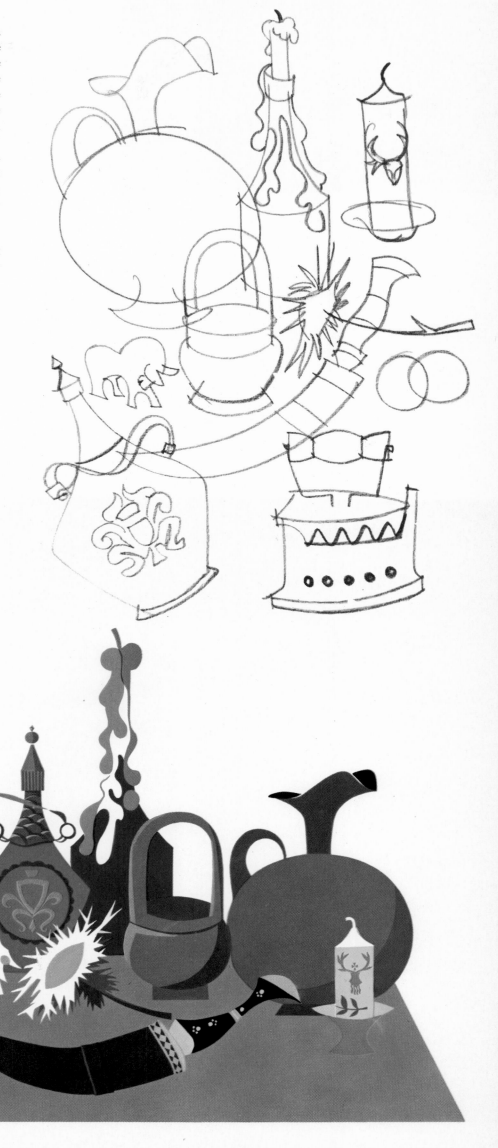

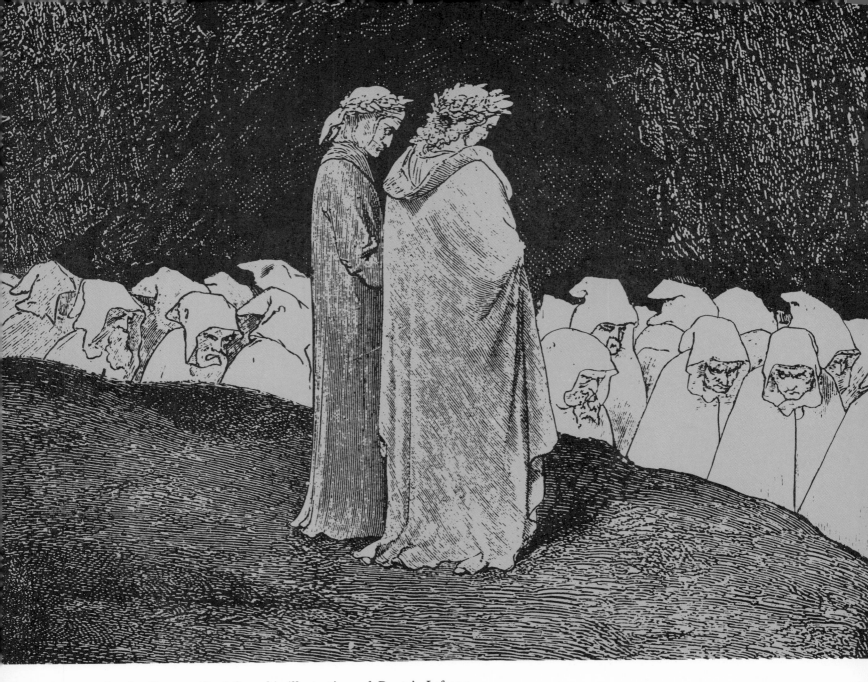

An engraving by Gustave Doré from his illustrations of Dante's Inferno.

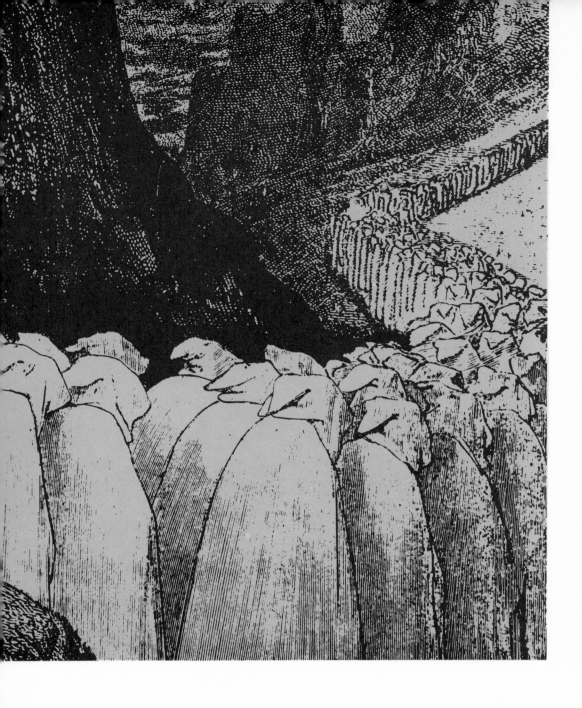

Graphic interpretation of

texts and music

Up to now we have studied only one type of subject, realistic ones. We have put all our efforts into transferring them on to paper as realistically as possible. It depended on originality, technique, synthesis of form as to whether or not the results could be considered satisfactory. Nevertheless we had our inspiration before us on the table, in the room or in the open air.

But there is another kind of subject which we have not yet looked at: suggested or invented subjects. To deal with this new task of depicting what we cannot see, we need a new gift—imagination. Imagination, however, does not mean creating from nothing. It means evoking pictures which arise in your mind while you are reading, or listening to a piece of music. Obviously it will be easier for you to imagine the characters in a book than to represent the sensations that music stirs in you; but in art nothing is impossible. You may rest assured that if you set about it methodically, you will find a way of capturing the numerous ideas which words and sounds bring to you. It is a real discipline, but also a new source of inspiration.

Book illustration

There is nothing more fascinating than bringing alive on paper characters whom you know so well from your reading but have never seen, although you have imagined them so often. Illustration consists in taking a story for a subject and, while sticking to the spirit of the text, giving it an entirely personal pictorial interpretation; that is, setting down on paper your own interpretation.

We have already agreed that pure invention does not exist. Everything we create is the result of the observation of reality. This applies equally to book illustration. Stories only provide the ideas, but to realize them we must have recourse to the images stored in our memories or look for them elsewhere. What will be completely ours will be the setting, the action and the costume but not the things themselves.

Let us examine together the four steps necessary for producing a good illustration.

CREATION OF THE CHARACTERS

Illustrating a book must be considered a part of a whole process. You cannot just illustrate one character; you must know the whole book, live the characters, follow the author step by step to discover the physical and moral features of his creations. With this in mind the main thing is to formulate your ideas about the central characters.

ATTENTIVE READING

Apart from reading the whole book, you must concentrate on the passage for illustration. You need to select the most representative scene, paying great attention to the description of the setting, the characters and their bearing. Try to picture the scene your reading suggests as realistically as possible.

RESEARCH AND DOCUMENTATION

Research is to a large extent conditioned by the work we wish to illustrate. The more exotic the setting, costume and appurtenances, the more necessary this is. Nothing is more off-putting than an illustration that fails to respect the period of the narrative. You must do this home-work properly or the result will disappoint.

DRAWING THE SCENE

Now that we know who the characters are, what they are like, the setting and the incident to be illustrated, it only remains for us to choose an appropriate technique and start on the drawing.

*Your illustration must take into account the **centre of interest** of the scene in order to give it its proper importance. Don't spoil the preparatory work by failing to carry out the final work satisfactorily.*

To give you a practical example of the process to follow before embarking on an illustration, let us take R. L. Stevenson's popular classic *Treasure Island*.

First, in order to create the characters, one has to go through all the passages of the book where they are described. The main character is Jim, a boy who finds himself among a gang of pirates with whom he goes through a series of perils and adventures. But the book neither gives his age nor describes any of his physical characteristics, so we must glean what information we can.

The second character, Long John Silver, ship's cook and cunning pirate, is more clearly defined in the text:

'His left leg was cut off close by the hip, and under the left shoulder he carried a crutch which he managed with wonderful dexterity, hopping about upon it like a bird. He was very tall and strong, with a face as big as a ham—plain and pale . . .'

'. . . I'm fifty . . .'

'. . . You're a lad, you are, but you're as smart as paint . . . What could I do, with this old timber I hobble on? When I was an A.B. master mariner I'd have come up alongside of him . . . in a brace of old shakes.'

From these simple descriptions one can already visualize the characters; the boy: lean, ingenuous, alert; the pirate: sly, confident, with evil eyes and a hawk-like nose . . . For the rest, it is up to one's imagination.

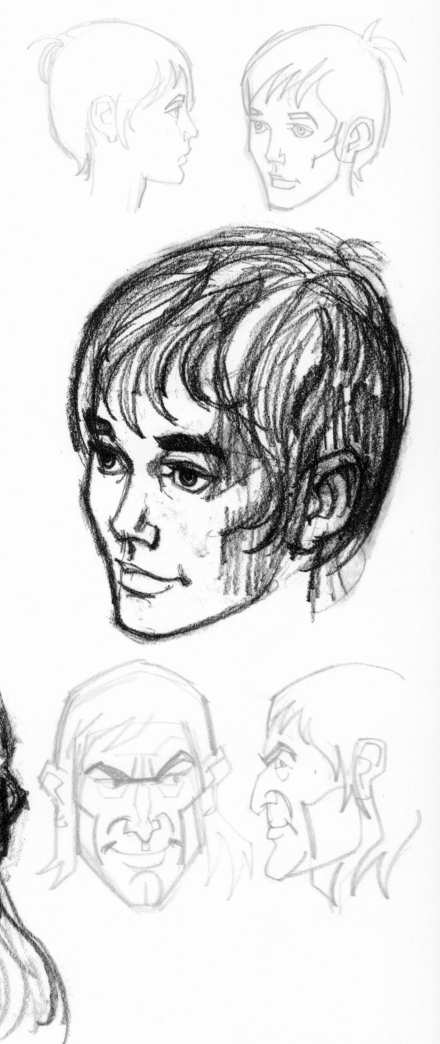

And now we come to the scene to be illustrated. Read it through carefully. So you can do this, two pages of the book are reproduced here. You will notice that the passages which contributed most to the pictorial evocation of the scene are underlined:

Meantime he (Silver) ran on, little supposing he was over-heard (by Jim from inside the barrel).

'Here it is about gentlemen of fortune. They lives rough, and they risk swinging, but they eat and drink like fighting cocks, and when a cruise is done, why, it's hundreds of pounds instead of hundreds of farthings in their pockets. Now the most goes for rum and a good fling, and to sea again in their shirts. But that's not the course I lay. I puts it all away, some here, some there, and none too much anywheres, by reason of suspicion. I'm fifty, mark you; once back from this cruise, I set up gentleman in earnest. Time enough, too, says you. Ah, but I've lived easy in the meantime; never denied myself o' nothing heart desires, and slep' soft and ate dainty all my days, but when at sea. And how did I begin? Before the mast, like you!'

'Well,' said the other, 'but all the other money's gone now, ain't it? You daren't show face in Bristol after this.'

'Why, where might you suppose it was?' asked Silver derisively.

'At Bristol, in banks and places,' answered his companion.

'It were,' said the cook; 'it were when we weighed anchor. But my old missis has it all by now. And the "Spyglass" is sold, lease and goodwill and rigging; and the old girl's off to meet me. I would tell you where, for I trust you; but it 'ud make jealousy among the mates.'

'And can you trust your missis?' asked the other.

'Gentlemen of fortune,' returned the cook, 'usually trusts little among themselves, and right they are, you may lay to it. But I have a way with me, I have. When a mate brings a slip on his cable—one as knows me, I mean—it won't be in the same world with old John. There was some that was feared of Pew, and some that was feared of Flint; but Flint his own self was feared of me. Feared he was, and proud. They was the roughest crew afloat, was Flint's; the devil himself would

have been feared to go to sea with them. Well, now, I tell you, I'm not a boasting man, and you seen yourself how easy I keep company; but when I was quartermaster, *lambs* wasn't the word for Flint's old buccaneers. Ah, you may be sure of yourself in old John's ship.'

'Well, I tell you now,' replied the lad, 'I didn't half a quarter like the job till I had this talk with you, John; but there's my hand on it now.'

'And a brave lad you were, and smart, too,' answered Silver, shaking hands so heartily that all the barrel shook, 'and a finer figurehead for a gentleman of fortune I never clapped my eyes on.'

By this time I had begun to understand the meaning of their terms. By a "gentleman of fortune" they plainly meant neither more nor less than a common pirate, and the little scene that I had overheard was the last act in the corruption of one of the honest hands—perhaps the last one left aboard. But on this point I was soon to be relieved, for Silver giving a little whistle, a third man strolled up and sat down by the party.

'Dick's square,' said Silver.

'Oh, I know'd Dick was square,' returned the voice of the coxswain, Israel Hands. 'He's no fool, is Dick.' And he turned his quid and spat. 'But, look here,' he went on, 'here's what I want to know, Barbecue: how long are we a-going to stand off and on like a blessed bumboat? I've had almost enough o' Cap'n Smollett; he's hazed me long enough, by thunder! I want to go into that cabin, I do. I want their pickles and wines, and that.'

'Israel,' said Silver, 'your head ain't much account, nor ever was. But you're able to hear, I reckon; leastways, yours ears is big enough. Now here's what I say: you'll berth forward, and you'll live hard, and you'll speak soft, and you'll keep sober, till I give the word; and you may lay to that, my son.'

Have you digested it? Good! Now let us see what the scene has suggested to us.

First of all, you must familiarize yourself with the setting of this conversation. We are on the deck of an old schooner. It is night-time. Jim is hiding in an apple barrel, from which, terrified, he overhears Long John Silver corrupting an honest sailor whom his ship-mates want to turn into a pirate.

So the characters are: Jim (in the barrel), Long John Silver (in his role as the corrupter), Dick (the sailor who allows himself to be persuaded) and the new arrival, Israel Hands (Silver's stupid ally).

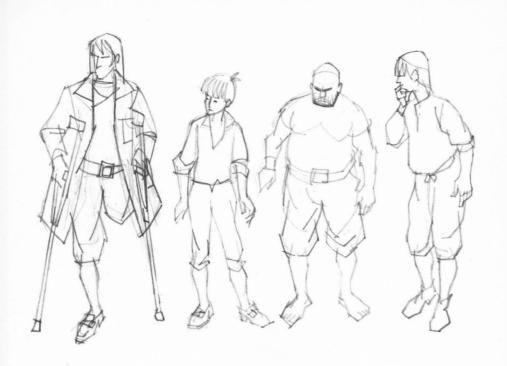

Now let us try and conjure up a clear picture of these characters.

Silver: *we know him already, often called 'Long John Silver' in the book. So he must be tall, lean and obviously have only one leg.*

Jim: *our young hero, slightly built, ill-clad and somewhat frightened.*

Hands: *fat, ugly and villainous.*

Dick: *young, indecisive and, like Jim, frightened.*

Now we can go ahead with the illustration. There are two centres of interest in this scene (i.e. two subjects). On the one side, Jim, hidden in a barrel; on the other, the group of conspirators. In sketch No. 1 more emphasis is given to the first subject—Jim in the barrel, with the pirates in the background. In sketch No. 2, the subjects are reversed. The pirates are in the foreground and the barrel containing Jim in the background.

You should plan out your illustrations on these lines. Leave the details for later. What matters is capturing the spirit of the scene. It is a bunch of conspirators. So we place the trio in a narrow circle. Their low voices force them to keep their heads close together. The barrel, on the periphery, represents another world, Jim's, of which luckily the conspirators are unaware.

Now look at sketch No. 3. We have chosen the second position (pirates in the foreground) because we need to have a close view of their expressions. We rely on these for evoking a real conspiratorial atmosphere.

This then will be the scene. At this point we must to some extent fix the poses by sketching them in lightly to see if we are on the right lines. If we are satisfied with the positions, we can proceed to the detailed part of the illustration.

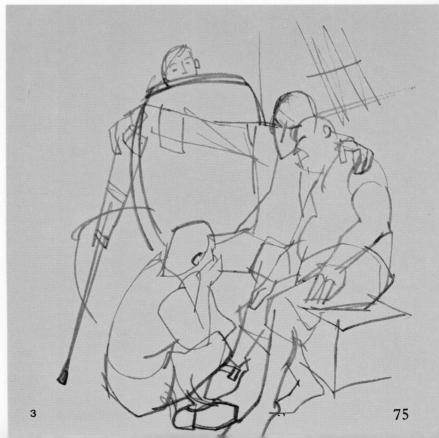

On this page you can see the completed picture. The details have been worked out and the facial expressions properly studied. The cunning villain in collusion with the stupid villain has already won over the waverer. Our young hero, Jim, watches the scene from his barrel horrified.

How does it strike you? Does it convey this impression to you? If so, it means we have solved the problem. Words have taken shape. Something has been created.

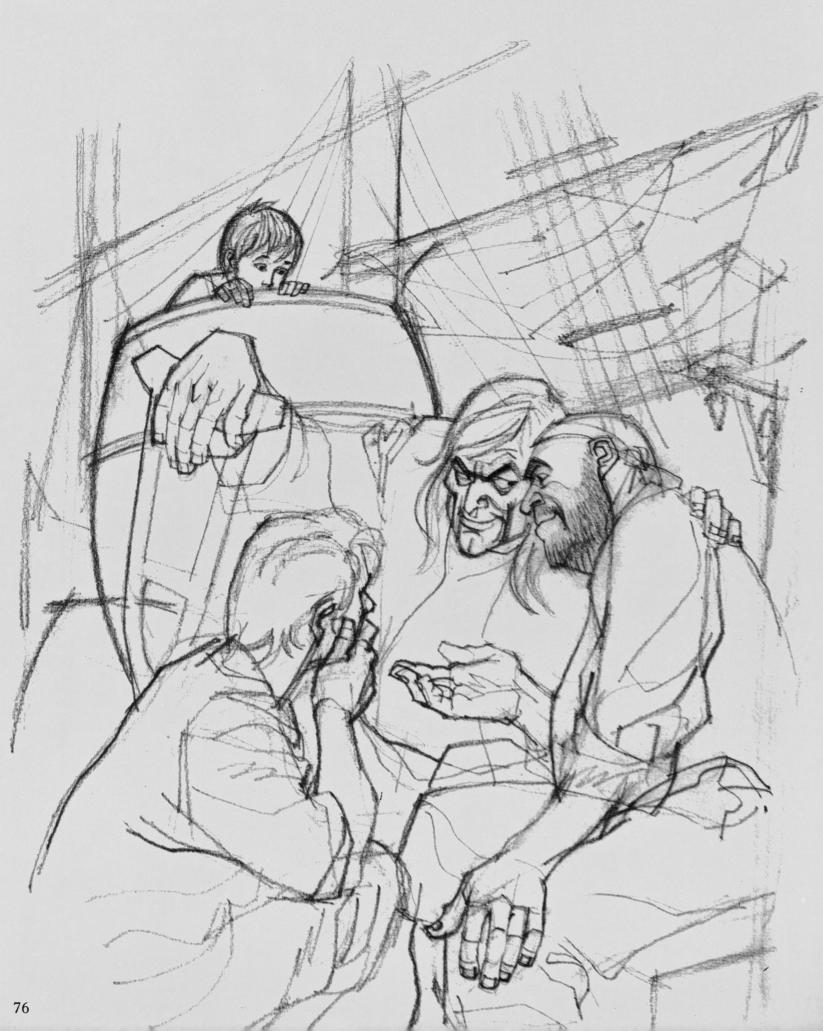

You have seen the birth of an illustration; but this is only one. There are many possibilities for every text, each of which invites many interpretations.

It is a mistake to think that the characters are the sole centres of interest. There are various types of illustration. The three main ones are:

1. The standard illustration. Here subject is created by the characters. These will be in predetermined postures and situated in a given setting, which is glimpsed as an item of secondary interest.

These illustrations usually monopolize the **middle planes** (complete figures occupying almost the whole area), like the one with the pirates just studied.

2. Sometimes the subject is not so much the characters as the emotion or expression. Such cases require **foreground treatment** so that the impact of these has full force.

3. But just imagine a book wholly illustrated with these foreground-type pictures. Not only would they be monotonous, we should not know where the scene is set.

There are, however, illustrations where the setting is the real subject. For these we make use of the **distant planes.** Figures are of secondary importance and only serve to animate the setting.

Here are three illustrations for the book *Heidi* which have been executed in a medium you have already seen, that of coloured pencils. It is admirably suited to a story for the young.

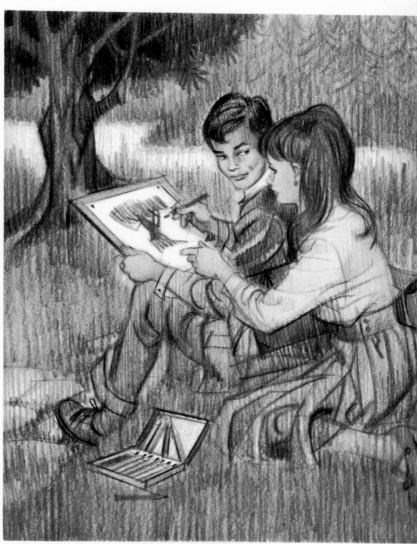

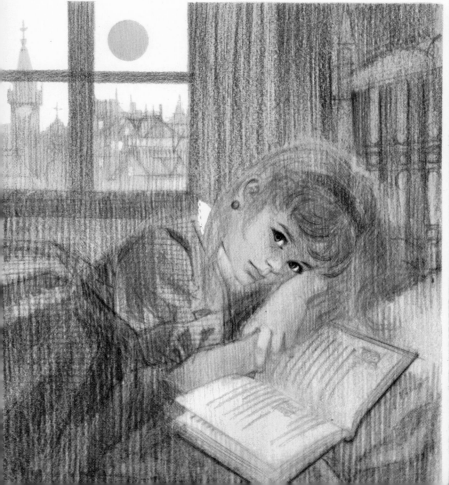

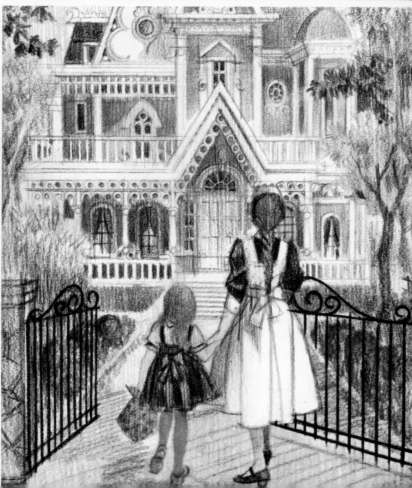

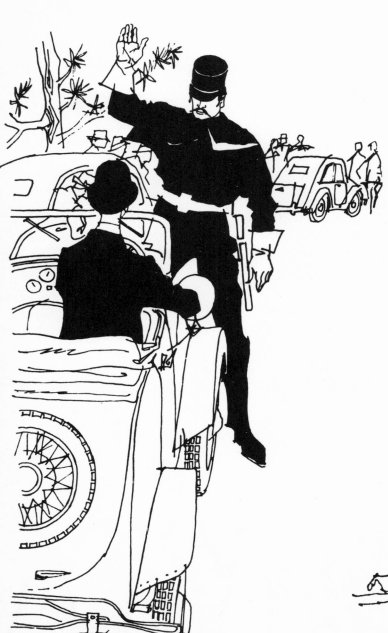

Another important factor in illustration is the **individualization** of the main character in the scene we represent.

Two different techniques fulfil this purpose. The first involves technical devices for emphasizing in the drawing the figures (one or more) that interest us. These effects are obtainable through colour, by the addition of details (a more careful description of the figures), through composition etc. What matters is that the figures should stand out.

The second technique, conversely, involves playing down all other figures or items except the figure or figures that interest us. To do this successfully you should draw the subsidiary figures impersonally, free of features that attract attention, or else show them in a back-view, a long way off or too close to be identified etc.

This is an example of 'reinforcement' of the main subject (the gentleman in the vintage car and the police officer), showing the exploitation of areas of black for technical ends.

Here is the reverse process. The subject is the horse (a mournful, white pony whose dull and monotonous kind of existence has been well expressed by the French poet Paul Fort), and so everything else (including the people in the trap) has been played down and depersonalized.

Music, symbolic art

Music is inherent in man. In fact there are no peoples or tribes without their own music or rhythms. Music—though we do not know why—has the power to produce particular sensations: joy, depression, tenderness . . . The images evoked by these sensations are intuitive and frankly abstract. So it is very difficult to illustrate music. No rules are applicable. Everything happens spontaneously, leaving us free to convey the pure impression produced by the music in the hearer's mind.

If, however, we try to find a solution to this problem, we can divide the pictorial expression of music into four more or less practical formulas. Music is a succession of sounds, produced by instruments to which harmony lends a meaning.

Hence we have four ways of illustrating music:

Illustrating the sounds
Illustrating the instruments
Illustrating the harmony
Illustrating the meaning

For illustrating sounds, we have to resort to a certain abstractionism: delicate lines corresponding to high-pitched notes, massive volumes to deep sounds, varied forms to a mixture of sounds etc.

If we want to take instruments for our subject, we can create attractive compositions, say, with a piano keyboard, violin strings, the curves of a trumpet . . .

For the illustration of harmony, geometrical